A GUIDE
...... *to*
H i s t o r i c
Downtown Memphis

A warm Memphis welcome
to our Scottish friends,

Bill Pull

A GUIDE
...... *to*
H i s t o r i c
Downtown Memphis

W I L L I A M P A T T O N

Charleston — London
THE
History
PRESS

Published by The History Press
Charleston, SC 29403
www.historypress.net

Cover images: *Courtesy of the Memphis and Shelby County Room, Memphis Public Library.*

First published 2010

Manufactured in the United States

ISBN 978.1.59629.906.1

Library of Congress Cataloging-in-Publication Data

Patton, Bill.
A guide to historic downtown Memphis / Bill Patton.
p. cm.
Includes bibliographical references.
ISBN 978-1-59629-906-1
1. Memphis (Tenn.)--Guidebooks. 2. Memphis (Tenn.)--Description and travel.
3. Memphis (Tenn.)--History. I. Title.
F444.M53P38 2010
976.8'19--dc22
2010026593

Notice: The information in this book is true and complete to the best of our knowledge. It is offered without guarantee on the part of the author or The History Press. The author and The History Press disclaim all liability in connection with the use of this book.

Contents

Acknowledgements

It's a tradition of sorts for an author to list his spouse last among the many people who gave assistance and support in the long and arduous task of writing a book, but I'm going to put my wife, Deborah, front and center where she belongs. Without her, this book simply would not have been possible—period. She helped immensely with virtually every aspect of the book; her support, encouragement, advice and countless hours spent patiently listening to my stories doesn't even begin to describe it. She deserves more thanks than I can ever give.

I'd also like to express my appreciation to the helpful staff of the Memphis and Shelby County Room at the Memphis Public Library and Information Center, especially Sarah Frierson, the world's greatest librarian; and to Memphis history guru Jimmy Ogle, from whom I've learned more than he realizes.

Thanks also to Memphis Jones, Jake Fly, Jessica Parker, Gary Hardy, Nora Tucker and everyone involved with Backbeat Tours, who day after day renew my love for this great city.

Introduction

It began with the interplay of great geologic forces: the tectonic lifting of a great ridge of rock and a mighty river twisting and slicing its way through the heartland of the continent, oozing thick mud over its alluvial plains.

The land was occupied by various Native American people, who were nomadic at first but then gradually adopted agriculture and settled into communities known collectively as the Mississippian Culture. Above the river, on bluffs crisscrossed with hunting trails, they built towns with massive mound complexes, tended fields of maize and lived, loved and died in a cycle of seasons repeating for thousands of years. In 1541 AD, these tall and handsome people greeted a traveler, Spanish explorer Hernando de Soto. He was unimpressed with the great river, finding it yet another obstacle in his futile three-year quest for gold; history records de Soto and his men, however, as the first Europeans to view the Mississippi River.

Sometime after the Spaniard's visit, the Mississippian people gave way to other newcomers, the Chickasaw tribe, migrants from the west. French explorers followed; unlike de Soto, the river to them was no obstacle but rather a highway connecting lands far to the north—rich in furs—with an outlet to the sea. They envisioned a great colony stretching from Canada to the Gulf of Mexico; near the mouth of the river they founded a settlement called La Nouvelle-Orleans and worked their way north along the great river highway, securing their new claim. A fort was built on the bluffs, but

disease, desertion and drunkenness proved to be foes as tough as the Chickasaw, and the French foothold was abandoned by 1740.

War in the East, begun by young George Washington in the Pennsylvania woods, soon brought two empires—Britain and France— into a seven-year global war. Britain emerged victorious. Half a world away, in the gilded drawing rooms of Paris, men in powdered wigs divided North America down the middle: French claims to land west of the Mississippi River were granted to Spain; those east of the river were granted to England. All fine and good, but it amounted to little more than words; neither Britain nor Spain could occupy the land. It remained the home of the Chickasaw, who were left in peace.

It would not be theirs much longer. Another treaty signed in Paris, this one between Britain and the newly independent United States of America, ceded English claims east of the Mississippi to the Americans. American traders began to appear among the Chickasaw and suddenly men in North Carolina were speculating in title to lands they had never seen along the Mississippi. Spain thought it best to make something of its holdings in the Mississippi Valley before the Americans, teeming steadily westward from their thirteen footholds on the Atlantic coast, could effectively grab it. In a preemptive move, the Spanish sent Lieutenant Governor Manuel Gayoso to purchase land from the Chickasaw in 1795. In exchange for food, shirts, brandy and firearms, the Chickasaw sold a small strip of land along the bluffs near the confluence of the Mississippi and Wolf Rivers; the next day, Spanish soldiers started clearing brush and trees for the construction of Fort San Fernando de las Barrancas (St. Ferdinand of the Bluffs). Six months later, though, in yet another treaty signed in a faraway land, Spain formally ceded all claims to the eastern Mississippi Valley above the 31st parallel to the Americans. Spain's colonial governor, thinking it unwise to have given up such a strategic position, delayed evacuation of the new fort but bowed to the inevitable two years later. In 1797, the soldiers burned the fort and moved to the west bank of the river.

Several months later, the Americans arrived and erected a small stockade on the site of the old Spanish fort, naming it Fort Adams in honor of the president. Later renamed Fort Pickering, it was moved in 1798 to a better site farther south atop the ruins of the old French fort.

Traders and squatters trickled in—tough frontiersmen from North Carolina and Georgia—though the land still belonged to the Chickasaw. The state of Tennessee was carved out of western North Carolina and became the 16th state of the Union in 1796. By 1818, a commission appointed by Congress and headed by General Andrew Jackson and former Kentucky governor Isaac Shelby negotiated the Chickasaw Cession, clearing the last remaining clouds on title to the lands of west Tennessee. Twenty-four years earlier, Jackson, along with his business partners John Overton and James Winchester, had purchased a five thousand-acre tract along the bluffs from a North Carolinian; with the ceding of Indian claims, they were now free to reap the rewards of their investment. The three absentee owners quickly had the land surveyed and, in 1819, laid out lots for sale in a new city. But what were they going to call this new city on the great river? Regarding the Mississippi River as the American Nile, Jackson, Overton and Winchester turned to antiquity and chose the name Memphis.

The founders had grand plans for the city. Streets were laid out, with four public squares and a promenade along the bluffs, although it would take some years for the plans to be fully realized. In the beginning, the city took shape around Auction Square, close to the original river landing and near where the Pyramid stands today. Marcus Winchester, son of founder James Winchester, became the city's first mayor and opened the first store, on the corner of Front Street and Jackson Avenue. A few of the pioneers who had been living on the bluffs before Winchester's arrival were given lots and encouraged to stay. Isaac Rawlings, an Indian trader who later became the city's second mayor, opened a store at the southwest corner of Main and Commerce, and Irishman Paddy Meagher opened a store and drinking establishment known as the Bell Tavern for the bell he hung in front on the east side of Front Street north of Overton Avenue. The Bell Tavern, frequented by the likes of Sam Houston and Davy Crockett on their travels, became legendary. It stood for nearly a hundred years—at various times a tavern, gambling den, store, church and warehouse—before being razed in 1918. Winchester's store, Rawling's store, the city's first cotton gin, its first courthouse, bank, newspaper office, the market buildings and the city's earliest houses—many built from wood salvaged from

abandoned flatboats—are likewise gone, swept away by the march of time and progress.

In 1826, Memphis was officially incorporated as a city, at the time having five hundred residents. By this time it had earned a reputation as a tough river town, a favorite port for flatboat men floating goods down river to New Orleans. In 1826, the first cotton bales arrived by wagon for transshipment down the river, and the city's cotton market was born. By the 1830s, Memphis was becoming an important commercial center and two rival towns began to be developed to the south: South Memphis, immediately to the south of the founders' land, and Fort Pickering, a community that grew up in the neighborhood of the now abandoned fort. Both of these communities would be annexed by Memphis as the city grew. Great paddle-wheel steamboats docked at the city's river landings, bringing fashionable ladies, silk-vested gamblers and prosperous planters from the delta. Mountainous piles of cotton bales crowded the riverbank, waiting to be hauled up to the warehouses on Front Street, while gentlefolk and charlatans alike hurried off to the Gayoso Hotel, the grandest hotel between St. Louis and New Orleans, or to the bars and gambling dens of Beale Street.

Over the next few decades, the city gained momentum with an influx of Irish and German immigrants escaping famine and political strife. The immigrants established new businesses, provided labor, built churches and introduced culture; from 1850 to 1860, Memphis was the fastest-growing city in the country, outstripping Brooklyn and Chicago. The Memphis and Charleston Railroad, completed in 1856, connected the East Coast and the Mississippi River for the first time, and Memphis boomed as a commercial distribution center. For better or worse, two commodities shaped the city's economy, created the fortunes on which the city was built and colored much of its subsequent history: cotton and slaves.

By the outbreak of the Civil War, the city was coveted by both the Union and the Confederacy; the river and the city's extensive rail network made it an important supply depot. At dawn on June 6, 1862, thousands of the city's residents lined the bluffs above the river to watch a confrontation between their Confederate fleet of "cottonclads" and a Union naval force that steamed out of the morning mist. By noon it was all over, and Yankee soldiers in blue occupied the city.

Spared the destruction of other Southern cities, Memphis suffered comparatively little under Union occupation. In many ways, it was business as usual. The city's merchants were conveniently placed middlemen between North and South, selling cotton and food to the Union and smuggling gunpowder, shoes and medicine to the Confederates. The war did bring dramatic changes to Memphis, however, as freed slaves fled by the thousands to the city and the Freedman's Camps established by Union authorities. The Freedman's Bureau provided rations, found jobs and started schools; when the war ended in 1865, most of the freedmen decided to stay. Many moved into the south part of town around Beale Street, increasing the black population from four thousand to fifteen thousand. Well before other cities, northern or southern, Memphis was on its way to developing a distinct African American community and, in subsequent years, that community continued to grow.

The city did not always adapt easily to these changes. On May 1, 1866, an altercation between blacks and Irish whites degenerated into a full-scale riot lasting three days; when the smoke cleared, over forty blacks had been killed, numerous more wounded and over one hundred black homes, churches and schools were burned in one of the worst race riots in the country's history.

Though the city—like much of the surrounding region and, indeed, the entire South—suffered an economic depression in the years immediately following the war, by 1870 it had largely recovered. At the beginning of the decade, the city was twice the size of its rival, Atlanta, and was poised to become the preeminent city of the South. But dark days lay ahead.

In 1873, following an unusually severe winter, the city had an outbreak of yellow fever that claimed over two thousand lives. The fever struck again in 1878. Within days, more than half the city had fled, many never to return; of the twenty thousand who remained, more than five thousand died. By the time it was over, the city had permanently lost one-quarter of its population. The city government, noted neither for its honesty or efficiency even in the best of times, tottered on the edge of bankruptcy. With its tax base suddenly eroded, the city defaulted on its bond payments, and the state legislature repealed the city's charter. Memphis simply ceased

to exist—at least as a corporate entity. Declared a taxing district, Memphis was placed under the control of a state commission, leaving residents little say in local affairs.

To make matters worse, in 1879, the fever struck yet again, and though milder than the previous year (causing only 595 deaths), it lasted longer and did even greater economic damage. It was the last straw for many of the city's wealthier citizens; many who had the means to move elsewhere turned their back on the city forever. With real estate values crumbling, thousands of its most productive citizens lost, its finances destroyed with no credit available for redevelopment and a reputation as one of the unhealthiest places to live in the country, the city's future looked bleak.

Under a fiscal austerity program and intelligent, honest leadership, however, the city fought its way back. Dr. D.T. Porter, the city's first president of the taxing district, took bold steps to clean the city environment. Though it was not discovered that yellow fever was mosquito-borne until the 1890s, many suspected that the city's poor sanitation was a factor; when Porter learned of an untested, revolutionary new type of sewer system designed by sanitary engineer George Waring, Jr., he immediately ordered its adoption in Memphis. The Waring System—also sometimes known as the Memphis System—was the first of its kind anywhere in the world and is now commonplace in cities around the globe. Porter also hired uniformed city sanitation officers to go house to house with cleanup instructions and to enforce strict new sanitary regulations. These and other measures had the unwitting effect of destroying mosquito breeding grounds in backyard wells and cisterns. The city was never plagued by yellow fever again.

The city also rebounded due to the strength of the black community. In 1878, in the midst of the terrible epidemic, blacks numbered close to 70 percent of the population that remained in the city and they provided virtually the entire workforce for the community. They collected and buried the corpses, distributed the relief supplies that poured in from the nation and served as nurses for the sick and dying. Two companies of black militia patrolled the streets to protect property and prevent looting. In the 1880s, under the taxing district, blacks served together with whites on

the police force, on the school board and in lesser offices of the city administration. Black leader Robert Church Sr., a sharp but prudent self-made millionaire who had been born a slave, displayed faith and optimism in the city's future by purchasing some of the early bonds to fund repayment of the city's debt and restore its charter. Others both black and white followed his example, and the city slowly clawed its way out of darkness. In 1891, its charter was restored, and Memphis regained full powers of home rule in 1893.

As if to make up for lost time, the city grew rapidly over the next decades. Spurned by Yankee investment capital, the city made do with what was on hand and turned to home-grown wealth from cotton and lumber. New levees turned swamps into rich farm land, and fortunes were made as lumber was cleared from the land. New railroads were built, and the Great Bridge was constructed, the first to cross the Mississippi below St. Louis. Known today as the Frisco Bridge, it made the city one of the nation's leading rail centers.

As business grew, so did population. Economic opportunity brought migrants from rural areas as well as an influx of immigrants from abroad; by 1900, Memphis had a population for the first time of more than 100,000, eclipsing both Atlanta and Nashville. Starting in 1898, a high-rise office building boom began, transforming the city skyline: the Continental Bank Building—now the Dr. D.T. Porter Building—completed in 1895, was followed by the Commerce Title Building (1904), the Tennessee Trust Building (1907), the Falls Building (1909) and the Exchange Building (1910); many other buildings all across town were renovated, expanded, refurbished and rebuilt. The Cossitt Library—the city's first public library—and the Grand Opera House rose downtown while merchant kings, flush with cotton money, erected ostentatious mansions in the fashionable neighborhoods on the edge of town. Two new train stations, Union Station (1912, now lost) and Central Station (1914) on South Main spurred the city's growth even more. New city parks were developed, including beautiful Overton Park, laid out by landscape architect George Kessler on plans drawn up, in part, by the designers of New York City's Central Park. Life became *fun* again. Race tracks and the city's first amusement parks were built on the outskirts of town, and

Sunday afternoons saw crowds of men in bowler hats and women in long skirts roller skating in Forrest Park. It was a freewheeling time of horse racing, gambling, whiskey and beer.

Welling up through it all was music. Brass band marches in the European tradition, classical symphonies, church organ recitals, vaudeville ditties and rural country music of both blacks and whites could be heard all over town. But it was the blues—the sounds of black laborers and sharecroppers—that captured the mood and melody of the times. W.C. Handy, a seasoned and popular bandleader newly arrived in Memphis, wrote a campaign song in 1909 for an earnest young reform candidate for mayor, E.H. Crump; it would be the first of a handful of songs from Memphis that would change the world. Published in 1912 as *The Memphis Blues*, it put the city's music on the national map; Memphis quickly became a mecca for black musicians who streamed up from the Mississippi Delta to make it in Beale Street's clubs and juke joints.

With the help of Handy's campaign song, E.H. Crump became mayor in 1909; he built a powerful political organization and held near-dictatorial sway over the city for the next forty-five years through Prohibition, prosperity, depression and war—leaving his mark upon the city like few others. Boss Crump died in October of 1954; the following year the city elected, for the first time in nearly fifty years, an independent mayor. But the new era was ushered in by two of the unlikeliest of figures: a recording engineer named Sam Phillips—born in Florence, Alabama, the hometown of W.C. Handy—and a teenager named Elvis Presley.

Phillips had come to Memphis as a radio sound engineer with a dream to make music of his own and to record the blues, the music that Handy unleashed here nearly fifty years earlier. He had an ear for talent, and while he had success with the likes of artists named Howlin' Wolf, B.B. King, Rufus Thomas, Ike Turner and Jackie Brenston and His Delta Cats, it was the arrival in his studio of Presley, the "dirty kid with the sideburns," that allowed him to achieve his dream. The phenomenal, meteoric success of Elvis brought others to Phillips's door—sons of sharecroppers named Cash, Perkins, and Lewis—and, before long, the country was moving to a new beat, a new sound created in the little studio on Union Avenue.

The post-war years brought more dramatic changes as Memphis, along with the rest of the nation, was confronted by the civil rights movement. In 1948, radio station WDIA became the first in the country to broadcast radio programming aimed at a black audience and through it the Memphis black community found a new voice, a new confidence. The city desegregated peacefully at first. There were sit-ins, demonstrations, protests and rallies but, in a few short years, buses, parks, museums, libraries and movie theaters were integrated quietly, without violence; the city was praised as an example of reason and decency. In South Memphis, a recording studio in an abandoned movie house caught the spirit of the times. Black or white, it didn't matter. Do you have talent? Step up to the microphone, give it a shot. Otis Redding, Isaac Hayes, the Staples Singers, Albert King, the integrated Booker T. & the MGs and dozens more gave the nation sweet soul music, a music of grit and emotional intensity.

Reversing habits and attitudes of more than fifty years proved to be difficult, however, and, as the nation moved deeper into the turbulent 1960s, tensions remained. The pace of change was too slow for many blacks; for many whites, who saw the traditional social structure crumbling around them, it was just the opposite. A strike of city sanitation workers brought the tensions boiling to the surface. The point of no return was reached on April 4, 1968, when Dr. Martin Luther King Jr. was assassinated on the balcony of the Lorraine Motel. It happened in Memphis—although it could have happened anywhere; King had lived in the shadow of death threats for years, and his killer, Illinois native James Earl Ray, had no previous connection with the city. But it happened here, and Memphis became the city that killed King. It dealt a heavy blow to the city, resulting in a wholesale flight of businesses from downtown; the city deteriorated into desolate, abandoned storefronts on desolate, abandoned streets as citizens fled from the violence, the uncertainty, the confusion. Building after building—the Peabody Hotel, the Orpheum, Goldsmith's and Lowenstein's department stores, even Beale Street itself—all were boarded up and left to die.

But to paraphrase Mark Twain—a frequent visitor to the city during his steamboating days—reports of the city's demise were exaggerated. The renovation and reopening of the Peabody Hotel

in 1981 kicked off the revitalization of downtown, a process still continuing to this day. Beale Street came back to life and new attractions and developments followed: Graceland, Sun Studio, Mud Island River Park and the Stax Museum; the Lorraine Motel transformed into the National Civil Rights Museum. Fortune 300 company AutoZone relocated its world headquarters to Front Street, and FedEx—founded in Memphis in 1971—made the city's airport into the busiest for cargo in the world. Trolleys returned to Main Street, taking tourists and locals alike to the new FedEx Forum, the Cannon Center for the Performing Arts, the Gibson Factory and AutoZone Park baseball stadium as well as to the restaurants, galleries and boutiques of the South Main Arts District. The city, home to the ever-expanding St. Jude's Children's Research Hospital and the new U.T.-Baptist Research Park, continues to develop into an important biotechnology center. Equally as important, downtown Memphis has become a great place to live: historic offices, banks and cotton warehouses have been converted to lofts and condos just a short walk or trolley ride away from restaurants, nightlife, sporting events and cultural amenities like the Orpheum Theater.

The chapters that follow are organized as individual tours, each offering a slice of Memphis: Memphis as it was and is today. The sites in each tour are loosely connected, some thematically, some simply by proximity. Most of the chapters are walking tours—the best way to see and experience the city is on foot—but some are driving tours, and some a mixture of both. Although there are historic areas and great things to see outside of the downtown core, for the most part the book focuses on the heart of the old city. It also focuses—again, with some exceptions—on the buildings, parks and sites that remain, places one can go to today and capture a glimpse of the past. Memphis has not always been kind to its historic structures: a great many have been lost but a surprising number have endured. The stories they tell are worth hearing.

Overall, this book is meant to be a practical, useful guide to Memphis's most historic streets, buildings and neighborhoods for both visitors and Memphis residents—for anyone wanting to learn about the history of the city by seeing how the city changed and what remains today.

Chapter I

Beale Street

In the first half of the nineteenth century, Beale Street was the main thoroughfare of South Memphis, a separate river town with its own bustling landing on the Mississippi River. Near the river landing were warehouses, saloons and rooming houses (some of the sort run by "professional" women); to the east, between Main and Third Streets, these rough and tumble establishments gave way to retail stores and respectable businesses of all kinds. East of Third Street the street's character changed again to a fashionable district where many country plantation owners maintained grand city residences.

From the late nineteenth century and well into the twentieth, Beale Street boasted a diverse mixture of Italian, Jewish, Greek, German and Chinese businesses. By the early 1900s, a wide variety of black-owned businesses lined its streets; it was a community of doctors, lawyers, insurance brokers, churches, theaters, banks, newspapers and retail stores that testified to the rising status of the city's African American population. Beale Street was the hub of it all, eclipsing for a time even Harlem as the "Negro Main Street of America."

By day Beale Street was a respectable retail and professional district; at night, there was whiskey, gambling, prostitution, drugs and murder, but, most of all, there was music. Music was everywhere: from the churches, with its rollicking gospel choirs, to the street corners, park benches, rowdy saloons and smoke-filled

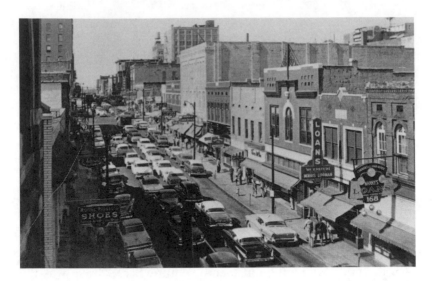

Beale Street, 1950s. *Courtesy of Memphis and Shelby County Room, Memphis Public Library and Information Center.*

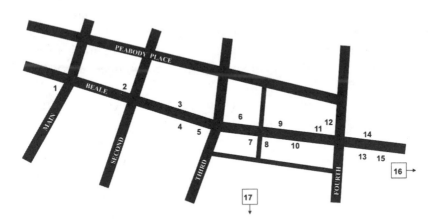

dives. During the mid-twentieth century, a string of musical greats launched their careers here, as the city blossomed as the creative center of blues music.

Post-war suburbanization and the general decline of downtown Memphis in the 1960s and '70s almost spelled the death of Beale

Street, and several misguided attempts at urban renewal nearly bulldozed it out of existence. Today, the Beale Street Historic District is thriving once again with restaurants and nightspots featuring top local musicians. Though changed in character from its heyday, it retains the distinctive allure of the Home of the Blues.

This tour starts at the Orpheum Theater at Beale and Main and proceeds east for three blocks along Beale to Church Park. Clayborn Temple, an important black church during the civil rights-era struggles, is south of the FedEx Forum on Hernando Street just off Linden Avenue one block south of Beale; the historic Hunt-Phelan House is a little farther afield at Beale and Lauderdale Streets. Although possible to reach on foot, it may be more enjoyable to visit these sites by car.

1. Orpheum Theater

203 South Main Street

Memphis's Grand Opera House, completed in 1890, originally occupied this location. In its heyday, the Grand Opera House was known as the finest and most elegant theater outside of New York City; it housed, in addition to the theater itself, the private Chickasaw Club on its upper floors where the elite of Memphis dined and danced. In 1907, it was purchased by the Orpheum Theater Vaudeville Circuit and featured vaudeville performances between the acts of dramatic plays. The theater burned to the ground in 1923 during a show that featured singer-comedienne-striptease artist Blossom Seeley (billed as "the hottest act in town").

In 1928, the present structure was built—nearly twice as large as the original Opera House—with gilded moldings, crystal chandeliers, lavish draperies and a magnificent Wurlitzer organ. The new Orpheum Theater featured movies and live performances from top acts such as Bob Hope, Mae West, Jack Benny, Louis Armstrong, Duke Ellington and many others. It became a Malco movie theater in 1940.

In 1934, the theater management tested Tennessee's blue laws, which made it illegal to sell tickets for any kind of theatrical

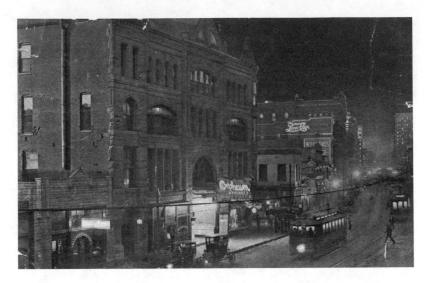

Grand Opera House at night, 1911. *Courtesy of Memphis and Shelby County Room, Memphis Public Library and Information Center.*

performance or movie show on Sundays. The management cleverly instituted Sunday Sandwich Shows, where the public could buy a sandwich and soft drink for forty cents and see a movie for free. The shows were enormously popular and, with the support of local political boss E.H. Crump, Sunday movies were soon legalized.

The theater is said to be haunted by the playful ghost of Mary, a twelve-year-old girl in a white dress and pigtails that is often seen sitting in the balcony in seat C-5. Said to have been struck by either a trolley or a carriage outside the theater and carried inside the lobby where she died, Mary has been a fixture here since the 1920s.

2. REPUBLIC NIGHTCLUB

126 Beale Street

This building, currently a nightclub, was the home of the Lansky Brothers Clothing Store until 1981. Samuel Lansky, an immigrant from Kiev, purchased a used-clothing store at this location in 1946

for his sons to provide them with secure jobs as their own bosses. Under the management of Bernard Lansky and his brother, Guy, the store originally sold Army surplus clothing. But Bernard Lansky, with his eyes on the colorful Beale Street nightlife parading past his store, soon changed to high-fashion custom menswear for musicians and folks stepping out on the Saturday night scene. After a few years of business, Lansky Brothers already had an impressive list of customers, including Count Basie, Lionel Hampton, Duke Ellington and B.B. King, but it was the kindness Bernard Lansky showed one day to a young Elvis Presley that cemented his reputation as Clothier to the King.

As Bernard Lansky tells it:

> *One day in 1952 I saw a bright young man walking on Beale Street. I had seen him around, always looking in the window, and I knew he went to church down there where they had gospel singing. It was Elvis Presley. I went out on the street and invited him inside. He said, "You have some nice stuff in there. When I get rich, I'll buy you out." I said, "No, don't buy me out, just buy from me."*

At the time, Elvis was an usher at Loew's State Theater (now lost, but, in 1952, it was just one block away on Main Street). He cashed his paycheck one day and made his first purchase: a $3.95 shirt. Later, while still attending Humes High School, he had Bernard Lansky create a distinctive ensemble set of black pants, pink coat and pink-and-black cummerbund for the junior-senior prom.

More from Bernard:

> *One day he came in and said, "I'm going to be on TV with Ed Sullivan." So, I got him dressed and told him how much it was. Elvis said, "I got a problem. I got no money." I told him, "Yes, that is a problem. But I'll tell you what, I'm going to float you." That was the key in the lock for him and me.*

For that simple act of kindness and respect, Elvis became a lifelong, loyal customer. Over the years, countless other musicians

and recording artists have made a pilgrimage to the store that came to define the style of early rock 'n' roll; the list of its famous customers is a veritable "who's who" of music royalty: Johnny Cash, Jerry Lee Lewis, Carl Perkins, Roy Orbison, Isaac Hayes, Frank Sinatra and many more.

The store—still operated by the Lansky family—is now located in the lobby of the Peabody Hotel; Bernard Lansky, the Clothier to the King, still works there almost every day.

3. King's Palace Café

162 Beale Street

The King's Palace Café occupies one of the more stylish and interesting buildings on Beale. Built in 1894, it features a cast-iron store front, a massive stone arch over the second floor window, an intricate brick cornice and a triangular cast-iron cap. At various times it housed furniture, dry goods, women's clothing and hardware

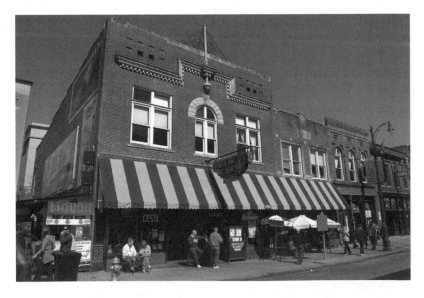

King's Palace Café. *Courtesy the author.*

stores, but, from 1928 through the 1960s, it was the home of Epstein's Loan Office. Loan companies and pawnbrokers were popular on Beale Street, where people frequently pawned their possessions between paychecks and purchased bargain items. Epstein's was one of the longer running of such businesses on the street.

The second floor housed professional offices of doctors, dentists, lawyers, Hooks Brothers Photography and the *Memphis World* newspaper.

The Hooks Brothers studio—one of the oldest black-owned businesses in Memphis—was a popular place for local black residents to have portraits taken. From 1907 through 1970, Henry and Robert Hooks photographed most of the African American society events in Memphis—college graduations, debutante balls, weddings, meetings of professional societies and charitable events—capturing an unparalleled visual record of the city's African American community.

The *Memphis World,* one of the leading black newspapers in the city, was published twice weekly from 1931 to 1973. It tackled many issues of the civil rights movement and documented everyday life in black Memphis.

4. A. Schwab's

163 Beale Street

Through more than a century and a half of change and upheaval, one Memphis business has remained unchanged: A. Schwab's Dry Goods store on Beale. Opened in 1876 just up the street from its current location, it is still owned and operated by the Schwab family. It is the only original business still in operation on Beale Street, and retains much of the flavor of old Beale, both inside and out.

The family business was originally located at 149 Beale and moved to its current location in 1912. In 1924, it expanded into the building to the left of the main doorway, previously occupied by dry goods merchants I. Goldsmith and Brothers (predecessor of Goldsmith's Department Store). Constructed in 1865, the two matched buildings feature interesting brickwork, a columned portico above the large

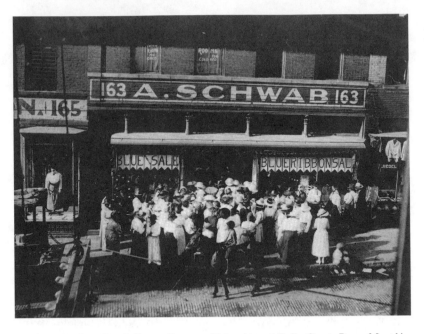

A. Schwab's Dry Goods Store. *Courtesy of Memphis and Shelby County Room, Memphis Public Library and Information Center.*

display windows and old-style attic vents. Inside, the wood floors, glass display bins and tin ceilings recall an earlier era. The second floor features a diverse collection of items from the store's history. Although now catering mostly to tourists, the store is famous for its wide variety of unusual items, everything from left-handed scissors to size seventy-two overalls. Since its founding, the store's motto has been "If you can't find it at Schwab's, you don't need it."

5. SILKY O'SULLIVAN'S

181 Beale Street

In 1891, Judge Charles Gallina built the Gallina Exchange Building, only the façade of which remains today supported by steel girders. The Gallina Exchange, once known as the Pride of Beale Street,

housed a bustling saloon open twenty-four hours a day and a hotel favored by the theatrical crowd from the nearby Orpheum Theater. Judge Gallina, a Shelby County magistrate, lived with his family on the top floor and held court in a second-floor room over the saloon. The saloon was also a rowdy gambling hall popular with the horse racing set; the judge himself was a frequent denizen of the racetracks at Montgomery Park and the Memphis Driving Park and owned as many as seventeen racehorses. After Judge Gallina's death in 1914, the building was used variously as a pharmacy, clothing store, dry goods shop and dentists' offices.

The intricate brickwork and arches of the exterior hint at the magnificence of the interior. Each hotel room had a marble fireplace, and the saloon was replete with expensive walnut paneling.

The steel girders supporting the façade were put in place in 1980, originally as a temporary measure after a fire gutted the interior of the building and a subsequent windstorm caused the collapse of the rear and side walls. Plans to rebuild the structure as a hotel never materialized, and the girders have become a quirky art piece to many and a now-permanent part of the streetscape.

6. Handy Park

Beale and Third Streets

The massive Beale Street Markethouse occupied this site from 1896 to 1929, replacing an earlier city markethouse here built in 1859. The three-story, brick building had a large centrally located dome and housed more than thirty meat, fish and vegetable stalls on the ground floor, with additional cold storage rooms for meat and fish. Starting at 2 a.m. every day, the surrounding streets were crowded with horses and wagons from the farms fringing the city.

The markethouse was torn down in 1930 to make way for Handy Park, which, along with Church Park at Beale and Fourth, became a center for blues musicians and popular jug bands. The statue honoring W.C. Handy, the Father of the Blues, was erected in 1960, two years after the composer's death.

Beale Street and Handy Park, 1950s. *Courtesy of Memphis and Shelby County Room, Memphis Public Library and Information Center.*

7. WET WILLIE'S

209–211 Beale Street

Two all-night drugstores operated here from 1896 through the 1960s: Battier's Drug Store (until 1929) and the Pantaze Drug Store No. 2. Both operated as unofficial emergency rooms for those injured by an excess of Beale Street revelry.

Around the corner, the side door on Hernando Street (Rufus Thomas Way) was the entrance to the Mitchell Hotel, which occupied the second and third floors. The hotel was owned and operated by club owner and music promoter Andrew "Sunbeam" Mitchell, and the second floor lounge—called the Domino Lounge and later renamed Club Handy—was one of the most popular music venues on Beale. Sunbeam Mitchell and his wife, Ernestine (who operated her own club and hotel, Ernestine & Hazel's, on S.

Main Street), took care of musicians, giving them meals or a place to stay when they were between gigs or low on money; it was said that Sunbeam never refused a bowl of chili to anyone with talent. Club Handy was famous for its house band—led for a time by B.B. King—and for impromptu, late-night jam sessions featuring out-of-town musicians such as Ray Charles, Little Richard, Lionel Hampton, Dizzy Gillespie and Sonny Boy Williamson.

8. P. WEE'S SALOON

317 Beale Street

On the site of the modern Hard Rock Café was once one of the most famous institutions on Beale Street, P. Wee's Saloon. P. Wee's was named after Virgilio Maffei, an Italian immigrant to Memphis

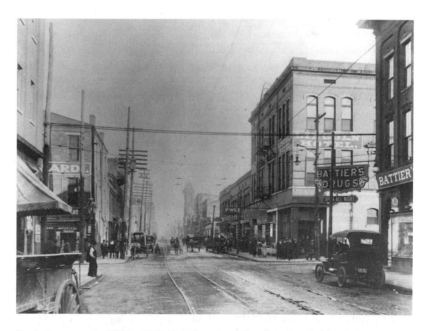

Beale Street, early 1900s. P. Wee's Saloon is on the right-hand side of the street, in center. Battier's Drug Store can be seen at right. *Courtesy of Memphis and Shelby County Room, Memphis Public Library and Information Center.*

in the 1870s who was only four and a half feet tall. He opened his saloon in 1884 after working as a bartender at the Gallina Exchange for two years. "P. Wee" Maffei was a colorful character on the Beale Street scene; a feisty, fiery man, he once bested the famous boxer Jack Johnson in an arm wrestling match and, on another occasion, won a wager by swimming across the Mississippi from the foot of Beale Street all the way to the Arkansas side. He was quite fond of gambling, and his saloon became one of the most popular gambling dens in Memphis; high rollers from all over the country came to the saloon to play.

The saloon was a rough joint: the house slogan was "We can't close, no one's been killed yet." Like many other gambling dens in town, the saloon had elaborate warning systems to protect against police raids, including a lookout with a secret buzzer hidden in his shirt.

In the early 1900s, P. Wee's was a musicians' hangout. At the time, the saloon had the city's only pay phone, and musicians would come here to contact band leaders, especially W.C. Handy, who acted as agent for a number of different bands and selected talent from the pool of musicians at the saloon. According to legend, Handy composed his famous *Mr. Crump* (later known as *The Memphis Blues*) at the saloon's cigar counter.

9. PALACE THEATER

324 Beale Street

The Palace Theater, torn down in 1972, was the premier entertainment showcase for blacks in the mid-South. In addition to movies and vaudeville shows, it also featured opera singers, dancers, acrobats, jugglers, chorus girls and an orchestra.

Starting in the 1920s, the Palace hosted amateur night talent contests that became enormously popular in the 1930s. The contest was hosted by WDIA deejays Nat D. Williams (also a high school history teacher) and Rufus Thomas on Wednesday nights. Anyone could get onstage, but they were at the mercy of the audience; if

the audience didn't like the act, the performer was run off the stage under a hail of boos and catcalls or "shot" with a toy pistol by the Lord High Executioner. Audience favorites were rewarded with prize money of up to five dollars and an invitation to perform again the following week.

To establish himself on the music scene, B.B. King entered the talent show week after week after coming to Memphis. He never won (which shows the quality of performers they regularly had), but Rufus Thomas, seeing talent in the young man, "took pity on him" (according to B.B.) and regularly invited him back.

In addition to B.B. King, many who performed on amateur nights later became stars: Bobby "Blue" Bland, Johnny Ace, Roscoe Gordon and Isaac Hayes, among many others.

Although the Palace was a segregated theater intended for black audiences, it also held Midnight Rambles for whites-only audiences with the same headline black entertainers. (The Orpheum Theater on white Main Street had a similar arrangement in reverse.)

10. OLD DAISY THEATER

329 Beale Street

Opened in 1917 as a movie house, the Old Daisy Theater with its gilded red half-dome entrance is a charming example of nickelodeon architecture from the early days of cinema. It was built by Sam Zerilla, a former clarinetist in John Philip Sousa's band; he was also responsible for the Pastime Theater, the city's first movie house for blacks.

In 1929, the theater was the scene of the glitzy, red carpet premiere of the short film *St. Louis Blues*, starring blues legend Bessie Smith, who arrived by limousine accompanied by W.C. Handy. The Old Daisy also featured live music; despite its small stage, it was a prime performing venue on the so-called Chitlin' Circuit from the 1930s up into the 1960s.

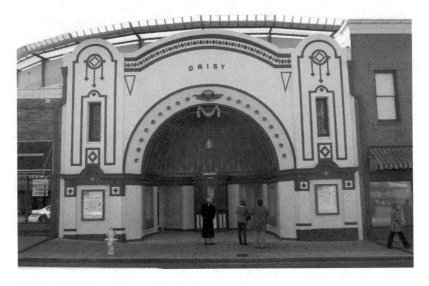

Old Daisy Theater. *Courtesy the author.*

II. RED ROOSTER

340 Beale Street

This building once housed the infamous Monarch Club, a gaming parlor built by politician, ward boss and "czar of the Memphis underworld" Jim Kinnane. Opened in 1910 at a cost of $20,000, it was the South's finest gambling hall, featuring a beautiful mahogany bar, gleaming brass fixtures, plush velvet-cushioned seating, a mirror-walled lobby and trap doors with secret exits in case of a raid. Upstairs, a dance hall and poker rooms attracted all kinds of patrons, including W.C. Handy, who enjoyed listening to the hall's piano thumpers.

In its heyday, the Monarch Club was known as the Castle of Missing Men for its reputation for murders; a mortuary located across the alley behind the club silently disposed of patrons killed on the premises.

12. W.C. HANDY HOUSE

352 Beale Street

This small shotgun shack was the home of W.C. Handy, the Father of the Blues, from 1912 to 1918. Originally located in South Memphis at 659 Jennette Place, this house was Handy's home when he wrote such classics as *St. Louis Blues*, *Yellow Dog Blues* and *Beale Street Blues*. Handy and his wife, Elizabeth, raised five children in this house. It is now open for tours.

William Christopher Handy was born in a log cabin in Florence, Alabama, in 1873. The son and grandson of African Methodist Episcopal ministers, Handy was exposed to church music at a young age. As a young boy, he saved money he earned from picking berries and secretly bought a guitar; when it was discovered, his father scolded him for bringing a sinful instrument of secular devil's music into the family home and ordered him to take it back. His

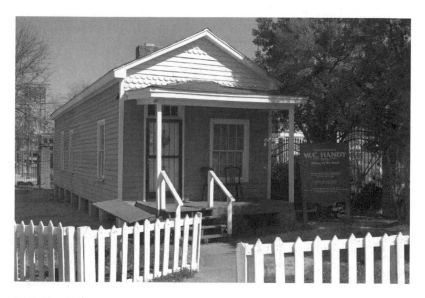

W.C. Handy House. *Courtesy the author.*

parents enrolled him in organ lessons, but Handy soon switched to the cornet, which he learned to play in the local barber shop.

In 1893, after short stints teaching and working in a factory, Handy joined Mahara's Colored Minstrels as a cornetist and traveled extensively throughout the country. Though he eventually became leader of the troupe, he left in 1902 to form his own band in Clarksdale, Mississippi. One day while waiting for a train at a station in nearby Tutwiler, Mississippi, Handy heard a black musician playing a guitar with a knife. The man was singing about going "where the Southern crosses the Dog," and Handy recalled "it was the weirdest music I'd ever heard." The man's singing was answered by the crying sound that his guitar made as the knife slid along its metal strings. The music made a strong impression on Handy; later, when a trio of black musicians played a primitive blues to the enthusiastic response of a white audience at a Clarksdale dance, he began to see that indigenous black music—derived from the work songs, field hollers and folk rhythms he had long admired—could achieve popularity even outside the black community.

In 1905, Handy and his band moved to Memphis and established themselves on Beale Street where there was plenty of competition. Handy began to work some of the elements of the blues into his band's arrangements, one of which—a song about the young Memphis politician E.H. Crump, who had pledged to clean up the good times on Beale Street—became the most popular in the band's repertoire. In the three-way mayoral race of 1909, Handy's band was hired by Crump, who outwardly sought support in the black community, to play the song at outdoor political rallies. The band's street-corner performances drew large audiences and generated much excitement; given that Crump won the election by only 179 votes, it could be argued that Handy's song *Mr. Crump* made the difference in the race.

In 1912, after being rejected by several popular music publishers, the song was published under the title *The Memphis Blues*. It is considered by many to be the first blues song to be published (although at least two other minor compositions titled as blues were published earlier that same year). *The Memphis Blues* became an instant hit nationwide, selling over fifty thousand copies by 1913.

Handy gained a huge following that established him and Memphis as important sources of the new musical style.

Handy formed his own publishing company with lyricist Harry H. Pace to capitalize on his success. Located on Beale Street in the Solvent Savings Bank building, the Pace and Handy Music Company published a series of blues numbers, each rising in popularity as blues music began to gain mainstream popularity. Handy's band was in high demand in such places as Church Park on Beale Street, the Falls Building's Alaskan Lounge (where they replaced a white band), riverboat excursions and country club dances. Demand became so great that for a time Handy employed over seventy musicians, providing Professor Handy's Band in any size from a quartet on up and playing several dances on the same night. In 1918, Pace and Handy moved to New York City; the partnership eventually dissolved amicably, but Handy continued to perform and compose until his death in 1958.

13. BEALE STREET BAPTIST CHURCH

379 Beale Street

Beale Street Baptist Church is the first brick church in the South built by and for former slaves to serve their own community. The congregation originated in 1849 in praise meetings of free blacks and slaves in the home of a white Baptist minister; city ordinances at the time prohibited blacks from preaching to a congregation and required a white man to be present during all services. After Memphis fell to Union forces in June 1862, these regulations were dropped, but the church continued under the leadership of a white minister until the ordination of Rev. Morris Henderson, a former slave, in 1864.

Although church membership grew rapidly as thousands of rural freedmen flocked to Memphis during and after the Civil War, it was not until 1865, under the leadership of Rev. Henderson, that the church raised enough money at a church fair to purchase this lot on Beale Street together with lumber for a temporary shelter. The congregation

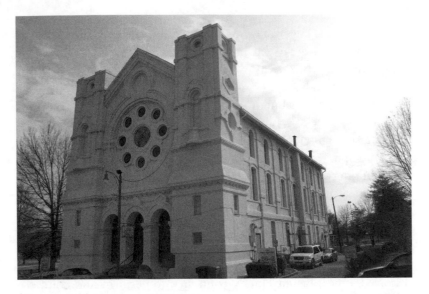

Beale Street Baptist Church. *Courtesy the author.*

worked for the next twenty-two years to pay for the magnificent church structure. It was designed by two of Memphis's leading architects of the day, Edward Culliatt Jones and Mathias Baldwin. The cornerstone was laid in 1871; the building was completed in 1885.

The twin towers flanking the large rosette window were originally much taller and considerably more ornate. The right-hand (west) tower originally supported an arched cupola-like structure topped by a large Celtic cross, but the cupola fell into the nave during a windstorm in the 1880s. The other tower, which featured a statue of St. John the Baptist with his arm raised to heaven, also had its share of misfortune: it was struck by lightning several times and a drunk climbed the roof one evening and hacked off one of the arms. In 1938, the statue was destroyed when workmen dropped it while trying to repair damage from yet another lightning strike. Nonetheless, the church remains a graceful and imposing structure; the interior features wide aisles, stained glass windows and a magnificent mural above the sanctuary. The church has hosted visits by Presidents Ulysses S. Grant and Theodore Roosevelt; in 1958, it was the scene of an emotional memorial service for W.C. Handy.

From 1889 to 1891, Rev. Taylor Nightengale, pastor of the church, and Ida B. Wells, a teacher at the nearby Clay Street School, published one of the earliest black newspapers in the city, the *Memphis Free Speech and Headlight*, from the basement of the church. Wells was a pioneer in the early civil rights movement who published many articles against segregationist laws and racial injustice while in Memphis.

14. SOLVENT SAVINGS BANK AND TRUST COMPANY

386 Beale Street

Established by Robert R. Church Sr. in 1906, Solvent Savings Bank and Trust Company was the first African American bank in the city. The bank played a crucial role in the economic development of the city's black community. By providing a sound financial base for the black community and emphasizing expansion of black-owned businesses, the bank fostered a general climate of opportunity for blacks in Memphis that was virtually unknown elsewhere in the South.

During the nationwide bank panic of 1907, when many older, established banks failed, Solvent Savings remained open; Church piled bags of money in the windows with signs stating that the bank had adequate reserves to satisfy all depositors. Solvent Savings survived the panic and became one of the leading financial institutions in the city.

In 1925, the bank moved to the corner of Beale and Third Streets. This building also housed a branch of another African American bank, the Tri State Bank, starting in 1946.

In 1913, W.C. Handy's music publishing company, the Pace and Handy Music Company, had its offices on the second floor of the building. The company remained here until 1918, when Pace and Handy moved to Times Square in New York City.

15. CHURCH PARK

Beale and Fourth Streets

Church Park was established in 1899 by Robert R. Church Sr., one of Memphis' leading black citizens. During the Union occupation of the city during the Civil War, Church—born a slave in 1839 to a white riverboat captain and a black seamstress—scraped together money doing odd jobs and embarked upon a career in business; among his first major ventures was a hotel and saloon on the corner of Second and Gayoso Streets, said to be "the finest colored establishment in Memphis." He invested heavily in real estate throughout the downtown area, especially after the devastating yellow fever epidemic of 1878, and became one of the richest men in the South.

Black Memphians were excluded from outdoor parks and recreational facilities until 1899 when Church built this private

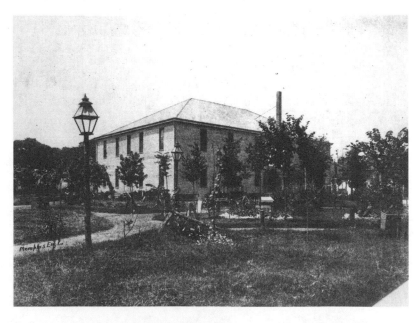

Church's Park and Auditorium, early 1900s. *Courtesy of Memphis and Shelby County Room, Memphis Public Library and Information Center.*

park on six acres at Beale and Fourth Streets. Church's Park and Auditorium was, in its day, the grandest outdoor facility in the city, with formal walks and gardens, picnic grounds, playgrounds, a bandstand and wandering peacocks. W.C. Handy's orchestra was a fixture in the bandstand during the summer months, and the park became a gathering spot for musicians of all types playing for tips.

The centerpiece of the park, however, was the two-thousand-seat auditorium, which became the cultural center for the region's black community; it was the only facility of its kind owned and operated by an African American anywhere in the country. The auditorium was used for civic and church meetings, conventions, commencement ceremonies and vaudeville shows; it also functioned as a community center for political events. President Theodore Roosevelt addressed an audience at the auditorium in 1902, and the Memphis branch of the NAACP was organized there in 1917. The auditorium was the meeting place for the Lincoln League—established in 1916 by Robert R. Church Jr., son of the park's founder—to register and educate black voters.

In 1921, the auditorium was razed and a new one built in its place, which stood until the 1970s. The outline of the original foundation is marked by the columns surrounding a memorial to Robert Church Sr.

16. HUNT-PHELAN HOUSE

533 Beale Street

The Hunt-Phelan House is one of the oldest and most historic houses in Memphis. Built between 1828 and 1832 with bricks made by slaves, it was designed by Robert Mills, architect of the Washington Monument and the U.S. Treasury Building in Washington, D.C. It has housed visiting American presidents Andrew Jackson, Martin Van Buren, Andrew Johnson and Grover Cleveland as well as Confederate president Jefferson Davis (a close friend of Civil War-era owner colonel William Hunt). Union general Ulysses S. Grant appropriated the house as his headquarters in 1863 when he came to Memphis to

Hunt-Phelan House. *Courtesy the author.*

control Union forces in the area. It is said that General Grant planned the Vicksburg campaign in the mahogany-paneled library.

During the Civil War, the house and grounds served as a hospital, caring for over nineteen thousand soldiers in 1864 alone. More

importantly, a small structure behind the gardens at the rear of the house became the site of one of the first Freedman's Bureau schools for African Americans. Union occupation of the city and the presence of the Freedman's Bureau contributed greatly to the quadrupling of the city's African American population during the war; the location of a Freedman's School here cemented Beale Street and South Memphis as the center of the city's burgeoning black community.

Originally the house was a relatively modest one-story home built in the popular Federalist style of the time. It was owned by George Hubbard Wyatt until 1845 when it was purchased by Wyatt's cousin, Elijah Driver, who added the two-story Greek-revival portico on the Beale Street side. Driver's daughter, Sarah Elizabeth, and her husband, Colonel William Richardson Hunt, presided over the home during the Civil War and yellow fever epidemics of the 1870s. Hunt enlarged the home yet again and also had an 11,050-square-foot servants' quarter built adjacent to the rear of the building.

The house remained in the family for six generations; descendants of Colonel Hunt lived in the house until 1993. By then, the house was the last remaining of the many fine mansions that lined the once-fashionable eastern end of Beale Street. It was converted briefly into a museum and is now an inn and fine restaurant.

17. CLAYBORN TEMPLE

280 Hernando Street

This church was built in 1891 as the Second Presbyterian Church but was sold in 1949 to the African Methodist Episcopal Church when the Presbyterian congregation moved to a new location farther east. Renamed Clayborn Temple, it became an important center of the black community; throughout the 1950s and '60s, it was the focal point of civil rights activities in Memphis. It was from this location, on March 28, 1968, that Dr. Martin Luther King Jr. led his final march—a march he never finished due to the outbreak of violence.

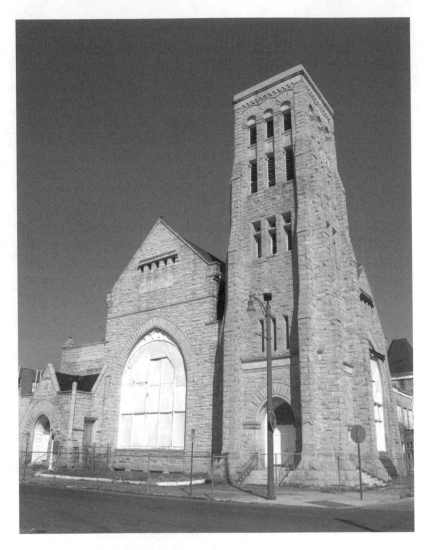

Clayborn Temple. *Courtesy the author.*

King returned to Memphis for a second attempt a few weeks later but was shot at the Lorraine Motel before the march could occur.

On April 8, King's widow, Coretta Scott King, led over twenty thousand marchers from Clayborn Temple through the city in the peaceful march that King had intended.

Chapter 2

Front Street

From the earliest days when farmers brought in their cotton with teams of oxen and camped on the slopes of the Public Promenade along the bluff's edge, Front Street attracted cotton traders and merchants of all kinds. Lined with cotton factors, seed merchants, hardware stores and sellers of farm implements, Front Street was the heart of the cotton trade, the engine of the city's economy for more than a hundred years; it was also notorious for the hidden whiskey dens and gambling joints in its many alleyways.

This tour starts at the site of the old Gayoso Hotel and proceeds along Cotton Row to Confederate Park, five blocks north.

1. Gayoso Hotel

130 South Front Street

On this site once stood the Gayoso Hotel; built in 1842, it was for many years the grandest hotel in Memphis. The current structure, built in 1901 after a fire, was operated as a hotel until 1948 when it was purchased by Goldsmith's Department Store and turned into an office and warehouse for its Main Street store. It is currently apartments.

The original 1842 hotel was built by Robertson Tropp, a wealthy planter and developer who desired to grace the then independent

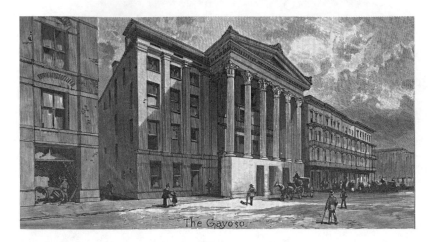

Old Gayoso Hotel. *Courtesy of Memphis and Shelby County Room, Memphis Public Library and Information Center.*

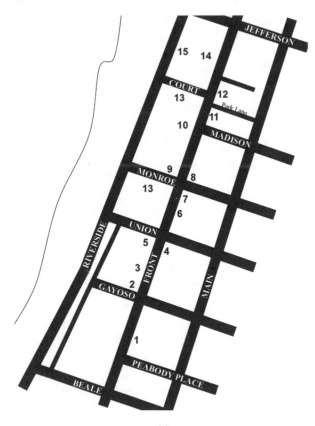

city of South Memphis with buildings of high architectural style; its grand Greek-revival portico was easily recognizable from the river, and the Gayoso Hotel became a Memphis landmark. With its own waterworks, gasworks, bakeries, wine cellar and sewer system, it offered amenities far beyond those available anywhere in the region, which included indoor plumbing—a rarity at the time—with marble tubs and silver faucets as well as flush toilets.

During Confederate general Nathan Bedford Forrest's raid in 1864, Captain William Forrest rode his horse into the lobby of the hotel and up the grand staircase in attempt to seize a Union general quartered there; the Yankee, however, was spending the night in the company of a friend, and escaped capture. It is said that, in frustration, Captain Forrest left several gashes on the stairway's banister with his saber.

On July 4, 1899, a fire spread from cotton warehouses across Front Street and engulfed the hotel. It was replaced with the current structure, a U-shaped building surrounding a courtyard screened from Front Street by a row of columns, no longer extant. The new hotel was one of the largest in Memphis; President Theodore Roosevelt lodged here, and future Louisiana governor and U.S. senator Huey Long was married here in 1913.

2. COTTON ROW

Front Street between Gayoso and Jefferson

Memphis began its rise as a cotton market in 1826 when 300 bales arrived here by wagon from Fayette County, Tennessee. By the time of the Civil War, nearly 400,000 bales a year were sold in Memphis; twenty years later, in 1880, three-quarters of the nation's cotton found its way to the bluffs. The opening of the Frisco Bridge across the Mississippi River in 1892, along with the building of cotton compresses—machinery that reduced bales to half size, something previously available only in port cities—expanded the city's role in the industry even more. By the turn of the twentieth century, Memphis was the largest inland cotton market in the world.

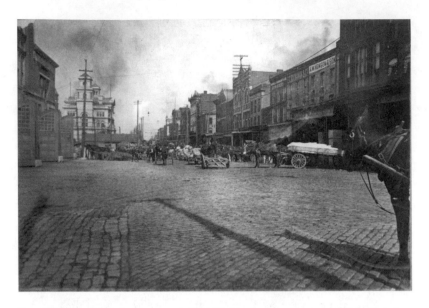

Front Street in 1900, looking north from Union Avenue. *Courtesy of Memphis and Shelby County Room, Memphis Public Library and Information Center.*

The city was full of businesses connected to cotton: sellers and shippers' offices, storage and compress facilities, insurance companies, wholesale grocers, dry good stores, seed merchants, hotels and bars all grew up around Cotton Row, as Front Street was called between Gayoso and Jefferson Avenues. The busy season was October through January, when long burlap snakes of cotton were piled on the sidewalk and white tufts floated through the air like snow. Heavy bales were loaded onto mule wagons at the riverfront and hauled up the bluff to the merchants' offices on Cotton Row for classification.

Merchants would class cotton according to its grade, staple and color in preparation for offering the bales for sale. There are nine grades, seven colors and seventeen staples of cotton, making nearly one thousand possible classifications. Classification was as much art as science, and the ritual of the classification process varied considerably depending on the personalities involved. Over samples laid out on broad wooden tables, a seller would recite pertinent facts to the buyer about the pedigree of the seed, the length and strength of the fiber, weather and soil conditions and other information; the names of

certain plantations would be related with a tone of reverence, much like a wine taster would recite a certain vineyard known for its fine grapes. Fortunes could be made or lost depending on a merchant's judgment, but, by tradition, sales were closed with a simple handshake.

In the twentieth century, modernization in the financing, planting, warehousing and selling of cotton decentralized the industry. Raw cotton is no longer necessary for samples, and many producers sell next season's cotton even before it is planted. Cotton is still a major commodity in the mid-South—within 150 miles of Memphis, there are more than a million acres of land under cotton cultivation—but progress in the form of electronic commodities trading and high-tech machines for classification have eliminated the need for centers such as old Cotton Row. Not incidentally, they have taken much of the romance out of the cotton trade as well.

The buildings of Cotton Row were constructed mostly between 1848 and 1928 to suit their uses for buying and selling cotton. The merchants needed buildings with wide entrances on the ground floor so that bales (weighing up to five hundred pounds each) could be moved in and out easily, and they needed large windows and skylights on the top floors where the visual work of classing took place. The buildings overall are unpretentious and utilitarian; the former offices of cotton factor J.G. Barton, (now Barton Flats Condos) at the northwest corner of Front and Gayoso is a good example of Cotton Row architecture. Cotton merchants, among the most powerful men in the city, felt little need to proclaim their status with elaborate facades; rather, the unadorned buildings are meant to suggest that they were frugal, sober, reliable men of business. (Their ostentatious Victorian mansions on Adams Avenue, however, tell a very different story.)

3. JOSEPH N. OLIVER BUILDING

99–103 South Front Street

Joseph Oliver came to Memphis from Cincinnati in 1860 to open a hat shop; when the Civil War broke out the following year, he turned to the more lucrative wholesale grocery business. Over

Joseph N. Oliver Building. *Courtesy the author.*

the next forty years he came to own numerous warehouse and storage facilities along the bluffs. In 1904, Oliver built this structure as a cold storage facility, the first of its kind in the South. The walls were insulated with thick panels of cork and cooled by river water pumped through a maze of pipes pressurized by a coal-burning plant in the basement. For many years the false windows were decorated with paintings of fish, chickens, eggs and other foods stored there; nonetheless, the building's resemblance to a theater is said to have fooled many a visiting theatrical and opera company who assumed such a grand structure would be the venue for their performance.

4. Cotton Exchange

65 Union Avenue

The Cotton Exchange Building was the hub of Cotton Row, where the buying and selling of cotton took place.

Following the example of New York and New Orleans, the Memphis Chamber of Commerce organized a cotton exchange in 1874 to bring order and information to merchants and growers. This building is the fourth in which the exchange resided; after renting space elsewhere on Front Street, the exchange was located at Second

Cotton Exchange
Building. *Courtesy
of Memphis and
Shelby County
Room, Memphis
Public Library and
Information Center.*

and Madison in two successive buildings until the current structure was built in 1925. Unlike the New York and New Orleans exchanges, the Memphis Cotton Exchange did not permit trading of cotton futures (the purchasing of cotton for delivery at a later date); instead, the Memphis exchange was a spot market, for cotton bought and sold on the spot. Today, most cotton is traded on the futures markets, but Memphis remains the nation's largest spot market for the commodity.

The old exchange trading floor is currently the Cotton Museum, highlighting the story of the cotton industry and its influence on economics, history and the arts. Old telephone booths have been converted to show films and recorded first-person accounts of what it was like to work in the exchange. The centerpiece of the museum is the former trading floor, restored to its appearance in the 1930s; now, as then, the trading floor is dominated by a large chalkboard showing cotton prices in different markets throughout the country.

5. HOWARD'S ROW

Union Avenue between Riverside Drive and Front Street

This row of buildings, built by Wardlow Howard in 1848 and originally known as Howard's Row, is one of the oldest in Memphis and was an early cotton trading center; in the 1850s, it also housed the slave market of Isaac Bolton, one of the largest of such markets in the city. The building at 47 Union Avenue, now housing the Memphis Convention and Visitors Bureau, served as a hospital during the Civil War, one of many buildings in the city put to such use. The building on the corner of Union Avenue and Front Street, now housing the Front Street Deli, got a new Front Street façade in the 1920s, when several feet of the structure was shaved off to accommodate the widening of the street. Farther down Union Avenue toward the river, the Timpani Apartments at 35–49 Union are in a renovated cotton office, one of the first buildings to be redeveloped downtown in the 1970s.

6. HART BUILDING

48 South Front Street

Built in 1899, this was for many years one of the most impressive buildings on Cotton Row, housing the cotton offices of Fulton & Sons. The building was designed by B.C. Alsup, the architect also of the Gallina Building on Beale Street, to which this building bears a strong resemblance.

Howard's Row. *Courtesy the author.*

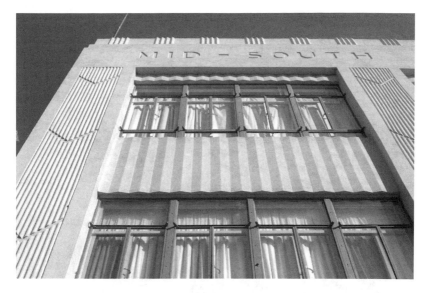

Mid-South Cotton Growers Association. *Courtesy the author.*

7. MID-SOUTH COTTON GROWERS BUILDING

44 South Front Street

This art-deco building housing the Mid-South Cotton Growers Association was constructed in 1936. Its concrete walls are incised with decorative elements in shallow, light-catching grooves. For years the building was used in advertisements for the Portland Cement Company as an example of the beauty of concrete construction.

8. SHRINE BUILDING

66 Monroe Avenue

Built in 1923, the Shrine Building was once the headquarters of the fraternal Al Chymia Shrine Temple. It retains today many original architectural features, including terrazzo floors, brass elevators, marble columns and observation decks. The functions of the former Shrine

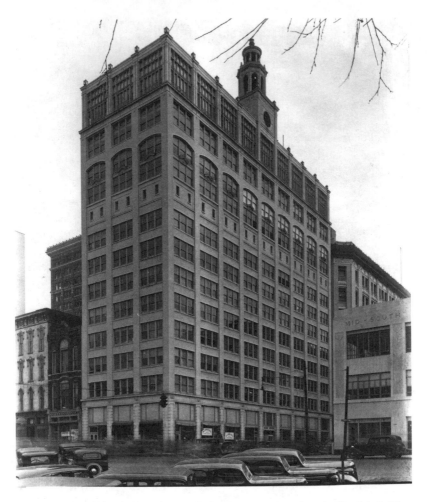

Shrine Building, 1940s. *Courtesy of Memphis and Shelby County Room, Memphis Public Library and Information Center.*

temple can still be read in the unusual variety of windows from street level to the roof. The lower eight floors, all with identical windows, contained professional offices; the temple itself began on the ninth floor with a billiard room, which required only small windows. The two-story arched windows of the next level mark the Shriners' large auditorium, while the floor above contained a library and lounge. The top floor housed a restaurant with magnificent river views.

The Shriners were forced to move in 1936 after being unable to meet their mortgage payments during the Great Depression. The building was renovated into apartments in 1976. From 2003 to 2009, the building was also the home to the Beale Street Caravan, a blues radio program that airs on over three hundred stations nationwide.

9. COSSITT LIBRARY

33 South Front Street

The modernist box that sits on this corner is a disappointing replacement for what was once one of the city's grandest buildings, an imposing, complex Romanesque structure of red sandstone with a beautiful, round tower. Behind the modern box, an addition to the original structure, built in 1924 of the same materials, gives only the faintest hint of the beauty of the 1893 library.

The Cossitt Library was the first public library in the city, built as a memorial by the daughters of Frederick Cossitt, who had lived in Memphis for a time before moving to New York City to make a great fortune. For a time, the library also housed the city's first museum collection.

10. UNIVERSITY OF MEMPHIS LAW SCHOOL

1 South Front Street

This building has served many functions over the years. Now the University of Memphis Law School, it was for many years the United States Customs House and later a courthouse and post office.

The original customs house, designed in 1876, was a proud structure with two large matching towers that defined the city's skyline from the river and served as a dramatic backdrop when viewed from Madison Avenue. The building was greatly enlarged in 1929 when it became a post office. The towers were removed; wings were added on the north and south ends; and the entire structure was

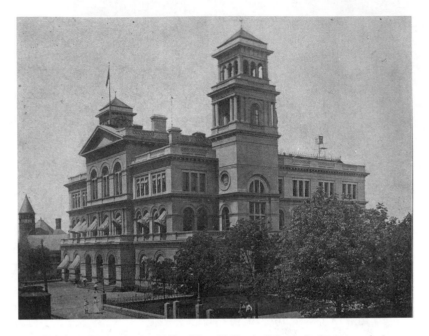

The Customs House, in the 1890s. The old Cossitt Library is the turreted building on the left. *Courtesy of Memphis and Shelby County Room, Memphis Public Library and Information Center.*

encased in a new outer wall of granite. The row of paired columns along the Front Street side were based on those of the East Front of the Louvre in Paris; the original columns of the 1876 building can still be glimpsed behind the windows.

In front of the building along the Front Street sidewalk, alongside a memorial to Memphis veterans, is the city's official Zero Milestone, from which all distances from Memphis are measured.

11. PARK LANE

This nondescript alley between Front and Main Streets with the innocent, pastoral name Park Lane was for many years a notorious alley known as Whiskey Chute. It was lined with saloons, oyster bars and gambling dens, filled with river roustabouts and other rough

characters shoulder to shoulder with respectable businessmen who used the alley as a shortcut to the post office and often stopped in for a nip.

In 1899, it was the site of the strange disappearance of wealthy real estate tycoon Jasper Smith. On the evening of May 26, he left his home on Orleans Street near Madison Avenue, where he lived with his sister and two nieces, telling the women he would be back before nine o'clock. His horse and buggy were found the next day abandoned in a suburban street several miles east off Poplar Avenue but there was no sign of Smith; investigation revealed that he was last seen in a Whiskey Chute saloon, although he was not known as a drinking man. Rumors circulated that he had withdrawn a large sum of money from his bank that morning and had possibly planned his disappearance because the women he lived with drove him crazy, but it was eventually presumed that he had been jumped in the dark alley by thugs, who robbed him and dumped him in the river. His body was never found.

Years later his family erected an impressive monument in Elmwood Cemetery featuring a life-size statue of Jasper Smith, along with a crouching lion. It is one of a very few grave markers in Elmwood without a body.

12. FALLS BUILDING

20–22 North Front Street

Built in 1902, the Falls Building was designed primarily for cotton merchants, with extra-wide windows to facilitate the classing of cotton. It is named for J. Napoleon Falls, a pioneer in the cottonseed oil industry.

The building had a rooftop nightclub called the Alaska Roof Garden, which was named for the cooling evening breezes from the river in the days before air conditioning. The Alaska Roof Garden was one of the city's premier nightclubs; W.C. Handy was the bandleader here, and it was here that he premiered one of his most famous compositions, *St. Louis Blues*, in November 1914.

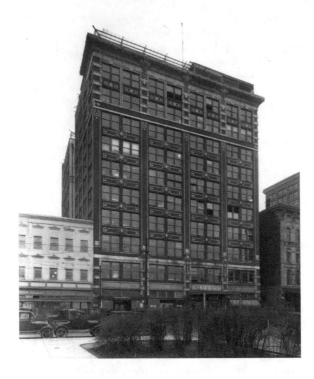

Falls Building.
*Courtesy of Memphis
and Shelby County
Room, Memphis
Public Library and
Information Center.*

The Tri-State Wireless Association, a group of early radio enthusiasts, made the city's first radio transmission from the roof of the Falls Building in June 1913. Eleven months later, the group radioed the score of a Southern Association baseball game between the Memphis Chicks (Chickasaws) and the New Orleans Pelicans, inning by inning, to an excursion steamer on the Mississippi River, seven years before the first official radio broadcast of a major league baseball game.

13. MONROE AND COURT STREETS

The streets running down to the river on either side of Confederate Park retain an interesting feature from the nineteenth century. The streets are eighty feet wide—double the width of ordinary city streets—to allow mule teams to zig zag up the steep grade with heavy loads of cotton.

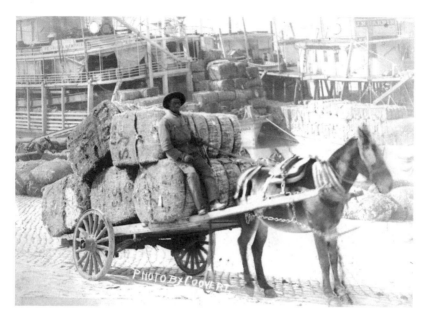

Mule wagon. *Courtesy of Memphis and Shelby County Room, Memphis Public Library and Information Center.*

14. Confederate Park

North Front Street and Court Avenue

The original 1819 plan of the city called for an open Public Promenade on the west (or river) side of Front Street, from Union Avenue all the way to Jackson Street to the north. Confederate Park is the only remaining open space that has not seen construction, due in part to its use in the city's early history as a garbage dump; trash was dumped over the bluff here and then transported by barge to the middle of the river.

In 1908, the site was cleaned and established as a park to commemorate the Confederacy. Several Civil War cannons were placed here, and a stone wall was built to resemble a crumbling fortification, despite the fact that the site never served in the city's defenses. (The Civil War cannons, along with an antique Spanish brass cannon in Court Square, were melted down during a scrap

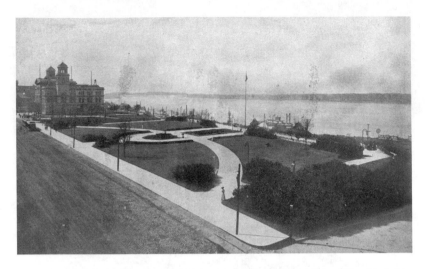

Confederate Park, 1912. *Courtesy of Memphis and Shelby County Room, Memphis Public Library and Information Center.*

metal drive in World War II and, for a time, were replaced with World War II and Korean War-era artillery.)

The statue of Jefferson Davis, former U.S. senator from Mississippi and president of the Confederate States of America, was added in 1964. Davis lived in Memphis after the Civil War from 1869 to 1876 while working as president of the Carolina Life Insurance Company. His memoirs, *The Rise and Fall of the Confederate Government*, were begun during his time in the city. Two of Davis's sons, William and Jefferson Jr., died here and were originally buried in Elmwood Cemetery before being reinterred in Mississippi.

The park contains a number of historical markers to Memphians associated with the Civil War, most notably Ginny Moon, a beautiful and charming young woman who served as a Confederate spy. Moon, who was born in Ohio but moved to Memphis with her mother just before the outbreak of hostilities, traveled frequently through Union lines, gossiping with Union officers for intelligence and smuggling quantities of medicine and other supplies under her large hoop skirts on her return trips south. She is said to have been engaged thirty-two times during the war. (This was to encourage the morale of Confederate soldiers. "If they'd died in

battle, they'd have died happy, wouldn't they?" she said. "And if they lived, I didn't give a damn.") Ginny was eventually caught, but she escaped and continued her espionage activities farther south; she was eventually imprisoned in New Orleans. She returned to Memphis after the war and ran a boarding house; she heroically remained in the city during the 1878 yellow fever epidemic and helped the sick and suffering. In 1919, at age seventy-five, she went to Hollywood and appeared in several silent movies with the likes of Douglas Fairbanks Sr. She eventually moved to New York and settled in Greenwich Village, where she died in 1926. She is buried in Memphis's Elmwood Cemetery.

15. BATTLE OF MEMPHIS

June 6, 1862

During the Civil War, just a few months after the bloody Battle of Shiloh, the Mississippi River here was the site of the Battle of Memphis. In the early morning hours of June 6, 1862, eight Confederate gunboats and rams—nicknamed cottonclads because of the cotton wedged in the spaces between iron plating and timbers to protect against enemy shot—lay in wait on the river for nine Union gunboats and rams approaching the city. The citizens of Memphis came out to watch the battle from vantage points along the Public Promenade; Mud Island was not yet in existence in 1862, and Memphians had a fine view of the battle from what is today Confederate Park. They could not have liked what they saw, though: within ninety minutes, seven of the eight Confederate cottonclads were sunk, captured or run aground, and the battle was lost. (The sunken vessels remain on the river bottom to this day.)

After the battle, a small detachment of Union troops landed and marched up the bluff. Mayor John Park famously refused to surrender the city; he added, however, that under the circumstances he would certainly acquiesce in its occupation. Some Union soldiers, followed by a large crowd of citizens, proceeded to the post office on Adams Avenue to raise the flag. The soldiers were led inside the

building and up the stairs, through a trap door and onto the roof, where they raised the Stars and Stripes to a chorus of boos. While the soldiers were on the roof, someone from the crowd below fired a shot (and missed)—the only act of direct resistance by the citizens. When the soldiers turned to go back down, however, they discovered that someone had closed and locked the door, trapping them on the roof to the delight of the crowd. The Union commander was not amused and sent word that they had five minutes to let his soldiers down, or he would start bombarding the town. The soldiers were let go, and the city settled in for occupation by the joyless Yankees. The city remained in Union hands for the remainder of the war.

In the battle, 182 Confederate soldiers died. Only one Union boat was destroyed, and there was only one Union casualty: Colonel Charles Ellet Jr., commander of the Union rams, who was wounded by a stray pistol shot; he later died in the hospital after contracting measles.

Chapter 3
Bluffs and Riverfront

The Mississippi River is the third or fourth longest river in the world (there are various methods of measurement), behind the Amazon, the Nile, and, depending on who you ask, the Yangtze. It begins in Lake Itasca in Minnesota and drains over 1.2 million square miles, or 41 percent of the North American continent—all or part of thirty-one states and two provinces of Canada. A drop of rain falling in Lake Itasca would take nearly ninety days to reach the Gulf of Mexico.

A very gradual southern slope has caused the river to take a twisting, serpentine path through a flood plain between thirty to one hundred miles wide from Cairo, Illinois, to the Gulf. Along this stretch of the river, known as the lower Mississippi, ground high enough to be safe from flooding is rare; the river's entire west bank, with the exception of one small outcropping at Helena, Arkansas, is below the river's flood stage. On the eastern bank, an elevated rock plateau stretches from Cairo to Vicksburg, but its edge actually touches the river in only four places, known collectively as the Chickasaw Bluffs; the fourth Chickasaw Bluff, the southernmost and highest of the group, is the site of present-day Memphis.

The river was the lifeblood of Memphis in its earliest days, bringing wealth and commerce in the form of cotton to its wharves on flatboats and, later, on graceful steamboats. It has also brought war, disease and refugees in times of crisis. Though railroads and, more recently, the airport, have taken the prime places in the city's transportation industry, the river remains a vital thread running through the history of Memphis.

This chapter is a walking tour of the bluff and riverfront, comfortably walked from Martyr's Park to the cobblestone landing, and a collection of additional sites—De Soto Park with its Indian mounds and the Chucalissa Archaeological Site—best enjoyed by car.

1. Martyr's Park

Channel 3 Drive off Riverside Drive

Martyr's Park was dedicated in 1972 to commemorate those who died serving others during the city's disastrous yellow fever epidemics of the 1870s. The twenty-foot monument was created by Memphis-area artist Harris Sorelle.

Martyr's Park monument. *Courtesy the author.*

Although Memphis had been exposed to yellow fever in 1828, 1855 and 1867, nothing prepared the city for the devastation the fever brought during the 1870s. An 1873 epidemic claimed two thousand lives in Memphis, a number that constituted at the time the most yellow fever victims in an inland city. In 1878, however, Memphis was forever changed by ten weeks of epidemic. The outbreak came north up the river from New Orleans and ravaged other cities, big and small, along the Mississippi River. Overall, more than twenty thousand died. Memphis was hit most savagely.

No one knew at the time that the disease was spread by mosquitoes; they believed it was caused by bad air arising from marshy or swampy ground. What they *did* know was that yellow fever meant, in most cases, a horrible death. The first symptoms were chills, nausea, severe pains in the head and back and high fever. After anywhere from a few hours to a few days, the fever subsided. A lucky few slowly recovered and were immune ever after. For the rest, however, the fever would return, and their skin and eyes would turn yellow. Internal bleeding, black vomit and delirium followed. The victims died in agony, filth and stench.

In late July and early August of 1878, the city had its first cases of yellow fever, and soon the panic was on. Within ten days of the first reported case, more than twenty-five thousand people fled the city (many never to return) by any means they could manage, with some going to places as far off as St. Louis and Cincinnati. Only about twenty thousand people remained in town, mostly the poor who could not afford to leave and had nowhere to go. In September, there were nearly two hundred deaths a day. Before the end of the epidemic, virtually all who remained would come down with the fever. For reasons that still aren't clear, the mortality rate among blacks was much lower than among whites. Over 90 percent of the whites who stayed in the city fell sick, and over 70 percent of those died; only 7 percent of the city's black population perished.

There were a few brave men and women, doctors, nurses and volunteers who stayed in the city to care for the victims, bury the dead and carry on the simple mechanics of living. Among these were the doctors of the Howard Association, a benevolent society organized to aid fever victims, and the city's ministers, priests and nuns who, regardless of the peril, would not turn away from those in the direst need, and it is to these brave and charitable souls that the park is dedicated.

2. Tom Lee Park

Riverside Drive at Beale Street

In the park are two monuments to Tom Lee, a black man who saved the lives of thirty-two white passengers aboard the steamer *M.E. Norman* when it capsized in the river on May 8, 1925. Lee, a levee worker, was on the river in a small open motorboat and witnessed the sinking of the steamer; though he could not swim and risked capsizing his own boat, he pulled as many people as he could from the waters, ferried them to safety on a sandy riverbank and then set out again until he rescued all he could find. As night fell, he gathered driftwood and made a fire for the survivors huddled on the beach and then set out in search of bodies.

New Tom Lee memorial, 2006. *Courtesy the author.*

When asked about his actions that day, Lee said simply, "I seen something that had to be done and I did it." He was honored as a hero by the city—highly unusual in the racial climate during segregation—and was given a house in North Memphis, along with a trip to Washington, D.C., to meet President Coolidge. In the 1950s, the city erected a monument to him (the obelisk), which praised him as "A Very Worthy Negro." In 2006, a new monument was dedicated to him, a larger-than-life image of him saving one of the victims. The statue is surrounded by thirty-two lights, representing each of the survivors he rescued.

The capsizing of the *Norman* was far from the worst steamboat disaster in the Memphis area. Capsizing, hitting a snag—a log or tree floating just beneath the surface that could rip a hole in a hull—boiler explosions and other accidents were not uncommon during the steamboat era. Henry Clemens, who, like his brother Samuel Clemens (better known as Mark Twain), worked on the Mississippi as a river pilot, died in Memphis after the boiler of his steamboat exploded just downstream; Mark Twain praised Memphis as the Good Samaritan City of the Mississippi for the

care his brother and others received in a makeshift hospital in the cotton exchange.

No river disaster was more devastating, though, than the wreck of the steamboat *Sultana* in April 1865; over 1,800 people were killed, making it the greatest maritime disaster in American history. (By way of reference, just over 1,500 died in the sinking of the *Titanic*.) The *Sultana* was overloaded with Union soldiers returning north from Confederate prison camps at the end of the Civil War; it had a capacity of 324 passengers, but there were more than 2,400 on board at the time. (One reason for this is the captain was paid one dollar per soldier and five dollars for every officer.) The overloaded boat strained against the strong springtime current, causing its boiler to explode; the explosion was so powerful, some of the survivors were rescued from trees along the Arkansas shore. Many who weren't instantly killed by the blast either burned from the hot coals or drowned.

The river changes its course constantly; the remains of the *Sultana* now lie deep in a soybean field on the Arkansas side, several hundred yards from the river today.

3. Cobblestones

Riverside Drive between Court Avenue and Beale Street

The Memphis Landing is among the best preserved of all of the nineteenth-century cobblestone river landings in the Mississippi River drainage basin, and, unlike landings in other major cities such as Pittsburgh, Cincinnati, St. Louis, or New Orleans, it remains largely intact in its historic dimensions and physical composition. Covering an area of over 300,000 square feet, it is composed of nine different stone types laid in a variety of different patterns. Over a hundred iron ring bolts and other nineteenth century mooring fixtures remain embedded in the stones, a testament to the heavy use of the landing by steamboats and all kinds of river vessels.

The Memphis Landing of today is the surviving portion of two once distinct areas: the Beale Street or South Memphis landing, developed between Beale Street and Union Avenue beginning in

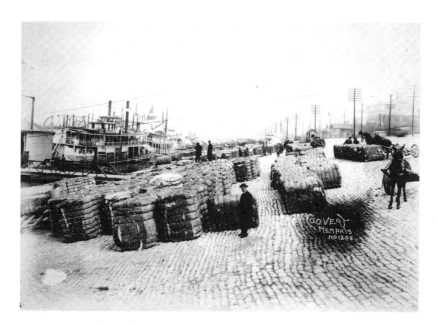

Memphis river landing and cotton bales. *Courtesy of Memphis and Shelby County Room, Memphis Public Library and Information Center.*

1838 and, just to the north, the area that came to be known as the Great Memphis Landing, first developed in the 1840s between Union and Jefferson Avenues.

Before 1858, the two landings were simply narrow strips of silt and clay at the foot of the bluffs; depending on the water level—which can vary considerably—river passengers and laborers were often forced to traverse two to three hundred feet of mud, muck and sand before reaching solid ground. The rapid growth of steamboat traffic in the 1850s and the need for greater convenience for the cotton factors of Front Street made stabilization of the landings a priority; in 1858, the city voted to pave the Great Landing, and later Beale Street Landing, with cobblestones. Work began in 1859; interrupted by the outbreak of the Civil War, it was completed in 1881. Despite numerous repairs and alterations, large sections of the original cobblestone paving projects remain in place today.

The growth of the nation's railroads slowly diminished the importance of the Landing, especially after the completion of the

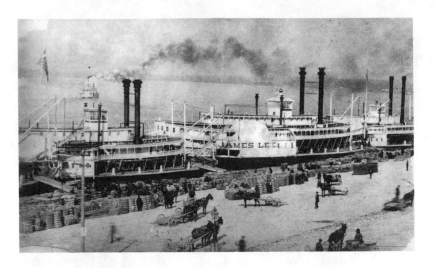

Steamboat *James Lee* of the Lee Line. *Courtesy of Memphis and Shelby County Room, Memphis Public Library and Information Center.*

Frisco Railroad Bridge in 1892. Still, the river remained a necessary connection between the rich cotton plantations of the Mississippi and Arkansas deltas and the industrialized North well into the twentieth century, and passenger steamers continued to use the landing until the 1930s.

The Great Landing has seen many curious sights over the years; one of the most colorful was a bewildered elephant that jumped overboard off the circus steamboat *Golden City* when it caught fire on the landing in 1882. The animal splashed to the cobblestones and wandered for a while along the wharf, investigating various stacks of cotton bales; finding nothing to his liking, he climbed the bluff at Union Avenue and headed into the city. A saloonkeeper on Front Street took him in, and kept him for a time for the amusement of his patrons. As reported in the newspaper, the saloonkeeper finally had to get rid of the elephant "when it nearly ate him out of house and home."

4. Mud Island

125 North Front Street (monorail station)

Mud Island was formed by a springtime flood of the Mississippi River in 1912. For nearly two years, a U.S. Navy gunship had remained anchored in the river near the outlet of the Wolf River, causing a sandbar to form around it; even after the ship was removed, the 1912 flood and subsequent floods added silt and sand. Within a year, the island extended all the way past Beale Street. The city feared that it would block access to the river landing, but engineers were confident that the river would soon wash it away. By the 1920s, however, it became apparent that it was a permanent fixture and there it sat, muddy and ugly and covered by floodwater every spring. It became the home of hardy folk who took advantage of free land and lived (unlawfully) in shacks on stilts. From 1959 to 1970, a downtown airport with one runway was operated on the island, with pontoon ferryboat service to the cobblestone landing.

It was seventy years before someone figured out what to do with it. With the building of the Hernando de Soto bridge in the 1970s, the U.S. Army Corps of Engineers dredged a deep channel in the river and deposited the mud and silt on the island, finally raising

Mud Island. *Courtesy the author.*

the height enough to prevent it from annual flooding. Mud Island River Park was built soon afterward, followed by the upscale Harbor Town development. Mud Island River Park contains an excellent museum of the Mississippi River, an amphitheater for summer concerts and the River Walk—a five-block-long reproduction of the lower Mississippi, complete with flowing water, tracing the course of the river from Cairo, Illinois, to the Gulf of Mexico.

On the southern tip of the island fly seven flags representing the sovereigns that have laid claim to the Memphis area since Hernando de Soto's discovery of the Mississippi River: Spain, France, Great Britain, the United States of America, the Confederate States of America, North Carolina and Tennessee.

5. DE SOTO PARK
(CHICKASAW HERITAGE PARK)

351 Metal Museum Drive

This park, named for Spanish explorer Hernando de Soto, is the site of several items of historic interest:

(1) The park's most distinctive features are several prehistoric Indian mounds, built between 800 and 1500 AD.

Between 1200 and 1400 AD, Native American people in the region had adopted what archeologists call the Mississippian culture, a term used to describe a wide array of complex, highly stratified communities in the Midwest, South and Southeast that shared a common belief system; the societies—organized as chiefdoms and involved in the intensive, large-scale cultivation of maize—are known today for their great mound complexes at such places as Cahokia near present-day East St. Louis, Illlinois. Mississippian settlements became increasingly centralized throughout the fourteenth and fifteenth centuries, and though they shared a common culture, evidence of defensive palisades and ditches at many settlements indicates frequent warfare between competing chiefdoms.

There were two such rival chiefdoms in the area that later became Memphis: one centered around the Parkin settlement, near modern

Bluffs and Riverfront

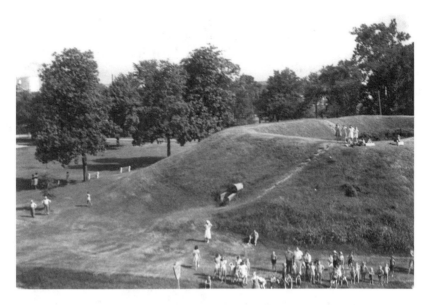

Indian mounds, De Soto Park. *Courtesy of Memphis and Shelby County Room, Memphis Public Library and Information Center.*

Parkin, Arkansas, thirty-five miles west of Memphis, and the other around the Nodena settlement, on the Arkansas bank of the river fifty miles to the north. In the immediate area of present-day Memphis was a collection of close to two dozen smaller settlements inhabited by the Tunica people and allied to the Nodena chiefdom; these settlements included the mound complex here at De Soto Park, along with a similar complex a short distance south at Chucalissa (now an archeological museum). The settlements were part of a province known as Quizquiz, encountered by de Soto in 1541; it is said that from this spot on the bluffs, near the large Indian mound, de Soto supposedly caught his first view of the Mississippi River.

(2) In 1739, a French fortification known as Fort De L'Assomption (Fort Assumption) was built here. In that year, Jean-Baptiste Le Moyne, Sieur de Bienville, led an army of twelve hundred Frenchmen into this area to eradicate the native Chickasaw Indians and secure the land for settlement by the French. The fort consisted of three bastions facing the land and two bastions fronting the river; the French also constructed a series of steep terraces on the slope

71

from the river to the top of the bluff. Despite the strength of the fort, the Chickasaw successfully resisted the French forces, who suffered from weather, disease, desertion and drunkenness. Fort Assumption was abandoned in March 1740, although the area was claimed by France for another sixty years.

In 1801, a small American fort, Fort Pickering, was built on this site; the top of the large mound on the edge of the bluff was hollowed out and made into an artillery emplacement and incorporated into the fort walls. Ammunition and powder was stored in a little brick bunker dug into the side of the mound (the entrance can still be seen from the street).

The first commander of Fort Pickering was Captain Zebulon Pike (father of the famous Rocky Mountain explorer). In 1809, he was replaced by Lieutenant Zachary Taylor, who forty years later became the twelfth president. Meriwether Lewis—of Lewis and Clark fame—was also briefly commander of the garrison at Fort Pickering, the first time the young Army officer held the responsibilities of command.

The site became less significant after the Louisiana Purchase (the Mississippi River was no longer the western border of the country), and Fort Pickering was abandoned in 1813.

After the victory in the Civil War Battle of Memphis, the Union army rebuilt Fort Pickering on a much grander scale. The new fort stretched for two miles along the bluff, from Vance Street to south of De Soto Park; it was large enough to accommodate ten thousand men and was designed with some of the most elaborate fortifications of the time. It became almost a city unto itself, and some maps and directories of the nineteenth century list "Fort Pickering" as a separate community.

6. National Ornamental Metal Museum

374 Metal Museum Drive

In 1884, a U.S. Marine Hospital was built here, the first government hospital in the area and the only one until the V.A. Hospital was built after World War I. In addition to its ordinary hospital functions, it

was the site of important early research work on yellow fever. All but two of the original buildings composing the Marine Hospital were torn down and rebuilt in 1936. The hospital itself closed in 1965; one of the 1930s-era buildings is now the National Ornamental Metal Museum.

7. Frisco Bridge and Harahan Bridge

Three bridges span the Mississippi near De Soto Park. The middle bridge and the oldest of the trio is the Frisco Bridge, known originally as the Great Bridge at Memphis. When it opened on May 12, 1892, it was the first bridge to cross the lower Mississippi River and the only bridge south of St. Louis at that time. Its construction was a monumental engineering achievement of its day. Built entirely of open-hearth steel, a newly developed material at the time, it has a 770-foot clear span and 75 feet of vertical clearance for river navigation, the highest of any bridge in the country of that era.

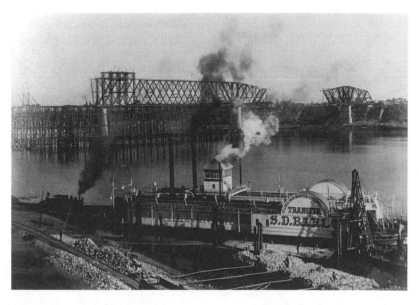

Transfer boat *S.D. Barlow* and Frisco Bridge under construction, 1891. *Courtesy of Memphis and Shelby County Room, Memphis Public Library and Information Center.*

The bridge was an economic boon to Memphis, providing easy access to a wealth of raw material and markets in the West and greatly increasing railroad traffic to Memphis. Prior to the construction of the bridge, small sections of train were ferried across the river on special transfer boats, a process that might take days to complete. This new bridge established Memphis as one of the nation's premier transportation centers, a reputation the city continues to enjoy to this day.

The opening day of the bridge was a festive occasion, with fifty thousand people in attendance listening to speeches from mayors, governors and senators while they waited to see if the bridge could sustain the weight of the first train; many believed it would plunge into the river. Eighteen locomotives—manned entirely by volunteers—were joined together to make the first crossing. The train of engines proceeded slowly across, stopping at the center of each span for measurements to be taken to determine if the bridge pilings remained solid. Once safely to the Arkansas side, the engines roared back across the bridge at sixty-five miles per hour to the delight of the crowd.

In 1913, construction was begun on the Harahan Bridge immediately to the north (or upstream) from the Frisco Bridge. It opened with two tracks of rail traffic in July 1916 and two lanes of automobile traffic in early 1917. The bridge carried motor vehicles on wooden roadways cantilevered like wings off each side of the railroad bridge until 1949 when the Memphis & Arkansas Bridge (now Interstate 55) opened. Crossing the bridge by car on wooden planks more than seventy feet above the river, protected only by a low wooden guardrail, was a white-knuckled experience for many drivers, especially those unfortunate enough to be on the span when a freight train rumbled alongside. In 1928, sparks from a passing locomotive ignited the roadway planks, causing one of the city's most spectacular fires.

Chapter 4

Main Street

M ain Street has come a long way since the 1800s, when a team of oxen was said to have drowned in a mudhole near Court Square. During most of the city's history Main Street has been the city's center of commerce, lined with hotels, restaurants, theaters, shops and businesses of all kinds. Suburban flight took a toll on downtown Memphis (and other major cities) in the latter half of the twentieth century, and many businesses deserted the downtown core. To lure shoppers back to the city, Main Street was converted into a pedestrian mall between Poplar Avenue and Peabody Place; the mall was inaugurated in 1976 with great fanfare by President Gerald Ford. Since that time, new restaurants, shops and condos have sprung up in renovated and restored historic buildings and are indeed revitalizing downtown.

The tour begins on Peabody Place at the south end of Main Street (still officially known as the Mid-America Mall, although hardly anyone calls it that) and ends five blocks north at Main and Madison Avenue.

1. MAIN STREET TROLLEY

Mule-drawn trolleys plied Main Street beginning in 1865. Though the mule cars afforded safe passage through the city's notoriously muddy streets, they did not come without drawbacks. Mules are

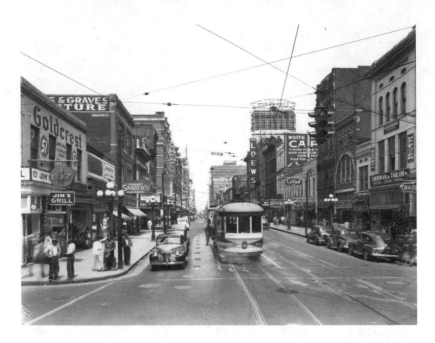

Main Street north from Beale Street, 1940. *Courtesy of Memphis and Shelby County Room, Memphis Public Library and Information Center.*

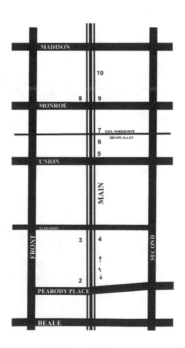

Main Street

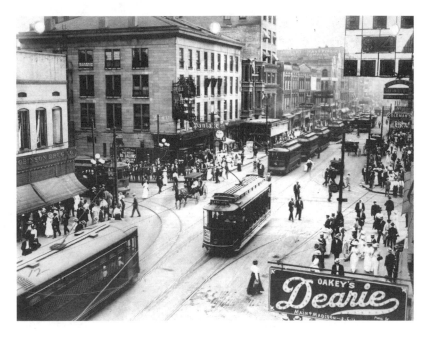

Main Street and Madison Avenue, 1912. *Courtesy of Memphis and Shelby County Room, Memphis Public Library and Information Center.*

famous for their obstinate nature, and Memphis's trolley mules were no exception. It was not uncommon for an animal, tiring of his labors or perhaps simply out of native contrariness, to jerk a trolley car off its tracks and lay down in the middle of the street; passengers were often asked to disembark, put shoulders to the wheels and aid in putting both trolley and mule right again.

Throughout the late nineteenth century the initial tracks expanded, and competing companies offered trolley service at a nickel a ride. Mule-drawn cars shared the tracks with the first electric trolleys starting in 1891, but it wasn't until 1895 that Memphis had a first-rate trolley system, operated by the Memphis Street Railway Company. Founded by Chicago businessmen C.B. Holmes and A.M. Billings, the Memphis Street Railway Company consolidated competing lines and greatly expanded trolley service throughout the city; by 1900, the company ran seventy-five cars on seventeen different routes, with over one hundred miles of

track. The company's lines not only connected residential areas with business and industrial areas but also ran to recreation areas beyond the city limits, fostering the growth of then suburban communities that were absorbed later into greater Memphis. The new electric trolleys were not universally popular, however. Small-town visitors thought the newfangled contraptions too fast and unsafe; one Mississippi bachelor, staying at the old Peabody Hotel for the weekend, stated that his main objection to the new electric cars was that their rapid transit made it impossible to kiss his sweetheart goodnight at her front gate—the drivers would not wait long enough.

Billings died in 1897 and leadership of the company fell to his son, C.K.G. Billings. The younger Billings's true passion, however, was for fast horses; he became a leading figure on the Memphis horse racing scene, overseeing the construction of two racetracks and organizing the Memphis Gold Cup, the nation's most prestigious horse race in the days before the Kentucky Derby. When the Tennessee legislature outlawed gambling on horse racing, he sold the company in disgust to a New York syndicate and returned to Chicago.

Trolley service continued until 1947 when the tracks were torn up in favor of transit buses. In 1993, the Memphis Area Transit Authority spent $33 million to bring streetcars back to Main Street with a fleet of colorful vintage trolleys on the new Main Street line. The scenic Riverfront Loop and the Madison Avenue Line were added in 1997 and 2004, respectively.

2. Majestic Grille

145 South Main Street

The restaurant gets its name from the Majestic Theater, a movie house that formerly occupied this site for over thirty years. Built in 1913 by Frank T. Montgomery, an early Memphis entrepreneur in the movie theater business, the theater's Hollywood Beaux-Arts façade features a colorful terra cotta design. It was one of the first theaters in the city specifically built to show motion pictures and was

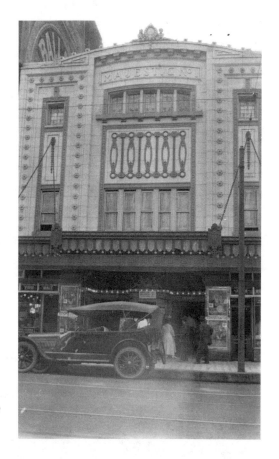

Majestic Theater, 1915.
Courtesy of Memphis and Shelby County Room, Memphis Public Library and Information Center.

the first to feature a balcony. Opening night of the Majestic was a major social event of the year, drawing a large crowd that tied up Main Street traffic for over two hours.

3. GOLDSMITH'S DEPARTMENT STORE

113 South Main Street

The Pembroke Square Building, home to the Belz Museum, was originally the flagship location of Goldsmith's Department Store. Goldsmith's was founded in Memphis in 1870 by German immigrant

brothers Isaac and Jacob Goldsmith, who, with a five-hundred-dollar investment, opened a dry goods store at 165 Beale Street, currently occupied by A. Schwab's. In 1881, the brothers moved to the east side of Main Street, opposite the current structure. The brothers arranged the store's merchandise by category, a novel idea in its day that made Goldsmith's one of the country's first department stores. In 1901, having outgrown the store at the southeast corner of Main and Gayoso Streets, they built a massive new location with fifteen acres of retail space (the current structure) across the street at the southwest corner of Main and Gayoso. Starting at closing time on the night of October 8, the old store's entire stock of merchandise was moved by handcarts to the new store on a specially built suspension bridge across the second floor windows. The new store on the west side of the street was ready to open at nine o'clock the next morning.

Goldsmith's Department Store. *Courtesy of Memphis and Shelby County Room, Memphis Public Library and Information Center.*

Jacob Goldsmith, president of the store following his brother's death, initiated a Christmas parade, preceding Macy's famous event by more than a decade, and in 1960, the store opened the popular Enchanted Forest for children. It was also the first Memphis store to install such features as air-conditioning, escalators and a bargain basement.

4. JOLLY ROYAL FURNITURE STORE

128 South Main Street

This streamlined art-deco building owes its distinctive decorative scheme of black and white tiles to its original tenant, the Black and White Store. At the time of its construction in 1947, it was the first all-new building to be built on Main Street in twenty-two years. Black and White Stores—a chain of working-class department stores in Tennessee, Arkansas, and Mississippi—started in 1904 as the Sam Shainberg Dry Goods Store, with its original shop on Union Avenue; the store's slogan was "Honest values, honest quality and honest service." When it opened in 1947, the Black and White Store at Gayoso and Main had a bakery, candy store and gift shop and featured men's and women's clothes, furniture, appliances, jewelry, cosmetics, shoes and furs. Newspaper articles of the day touted the store's "innovation" of having "two complete luncheonettes, one for white, and one for negro customers. Each has a separate dishwashing unit and the white side will have all white employees and the negro side all negro employees." Such was the state of affairs in the days of Jim Crow.

The building subsequently housed the Jolly Royal Furniture Store. It is said that in 1974, when driving past the Jolly Royal store, Elvis Presley stopped his car and within a half hour purchased every piece of furniture that reminded him of Hawaii, including a sofa and chairs covered in faux fur, lime green shag carpeting and a chair with arms of carved wooden snakes. Another version of the story, often told, is that it was Elvis's father, Vernon, who saw what he called "the world's most ugliest furniture" in the store window; when

he returned to Graceland and told Elvis about it, Elvis immediately came to the store and bought the pieces simply to annoy his father. The furniture formed the basis of the famous Jungle Room in Elvis's Graceland mansion.

5. Radio Center Flats

66 South Main Street

Radio Center was built in 1948 as the home of radio station WMPS and later housed the legendary station WDIA. Broadcasts from this building shaped the popular culture of both Memphis and the country for over fifty years.

WMPS, which began broadcasting in 1923, was primarily a country-and-western station that featured music by the Carter Family, Jimmy Rogers and Bill Monroe, among others; it also originated its own programming, which helped showcase the early careers of artists such as Kay Starr and Eddie Arnold prior to World War II.

In the 1950s, the station's half-hour broadcasts of the *Eddie Hill Show*—featuring "hillbilly" musicians and songwriters Ira and Charlie Louvin as well as its morning and noonday broadcasts of the famed Blackwood Brothers gospel quartet—influenced such later legends as Elvis Presley and Johnny Cash, who regularly tuned in from his home fifty miles away in Dyess, Arkansas. And while Elvis got his first big break on rival station WHBQ, it was here at WMPS that program director and disc jockey Bob Neal introduced Cash's first hits, *Hey Porter* and *Cry, Cry, Cry* to the public. WMPS continued to broadcast from Radio Center until the early 1980s.

In 1985, Radio Center was occupied by the country's premier African American radio station, WDIA, known as the Goodwill Station. WDIA first came on the air in 1947 from studios at 2074 Union Avenue; like WMPS, its format was country and western and light pop, but it had little success. Before giving up on the station entirely, its white owners, John Pepper and Dick Ferguson, decided to hire a black man, a local syndicated columnist and high school teacher Nat D. Williams, to broadcast a program called *Tan Town*

Jubilee. It was the first radio program in the country specifically aimed at a black audience and was an instant success. WDIA soon became the number one station in Memphis.

As the first major media of any kind to directly address black Memphians, who at the time constituted 40 percent of the city's population, WDIA empowered the Memphis black community in the 1950s and '60s. The station had local news and public interest shows that featured job listings and other "public bulletin board" items of interest to its audience. WDIA's most lasting contribution, however, was arguably the music played on the air. The station's on-air personalities such as Rufus Thomas and Riley King—better known as B.B. King— have since sealed their places in the history of Memphis music.

Though B.B. King is now familiar to music fans everywhere, he was a virtual unknown when he arrived in the city in 1948. His first stop was Beale Street's Handy Park, where he had something of a rude awakening; as he recalled years later, "all my confidence from all those Saturdays playing all those little Delta towns vanished— just like that. Before Beale Street, I thought I was pretty hot stuff. After Beale Street, I knew I stunk. The cats could play rings around me." Undeterred, however, and looking for work, he approached a club owner in West Memphis who told him that he could get a regular gig at the club only if he could become the host of a radio show to publicize the café. King went to WDIA, where he won a fifteen-minute radio show by writing a jingle for Pepticon (a popular all-purpose tonic). He became known as Pepticon Boy and started to gain a following; King himself has said that this was when his career started to take off. Performing blues music on the air, he soon shuffled off the nickname Pepticon Boy and became known as Blues Boy King, which he later shortened to B.B.

The station's programming of black music—blues, gospel, R&B—was unlike anything heard on the airwaves at the time. In the racially stratified South of the 1950s, the airwaves were the one thing that couldn't be segregated, and WDIA exposed white listeners to a rich and underappreciated cultural resource. Filtered through the consciousness of white teenagers such as Elvis Presley, who regularly listened to WDIA broadcasts, the station contributed greatly to the birth of rock 'n' roll.

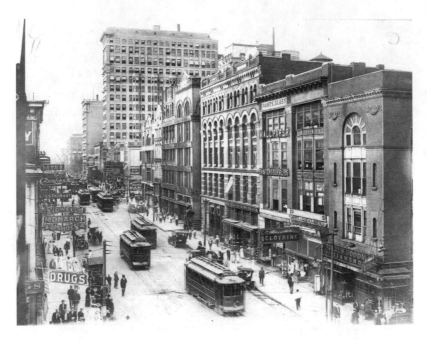

Main Street, 1912. The Memphis Queensware Building is at center. *Courtesy of Memphis and Shelby County Room, Memphis Public Library and Information Center.*

6. MEMPHIS QUEENSWARE BUILDING

58–62 South Main Street

One of the finer commercial Romanesque buildings remaining in the city, the Memphis Queensware Building, built in 1881, housed Lemmon and Gale Wholesale Dry Goods, for many years one of the largest such stores in the city.

7. GENERAL WASHBURN'S ESCAPE ALLEY

South Main Street between Union and Monroe Avenues

The street gets its name from Confederate general Nathan Bedford Forrest's daring raid on August 21, 1864.

Main Street

A large Union force, some twenty thousand strong, had been sent to find and destroy Forrest's cavalry and engage the rebels near Oxford, Mississippi, sixty miles southwest of Memphis. Forrest, finding himself outnumbered and nearly surrounded, made the bold and unorthodox decision to divide his forces, leave a small force to keep the Union army occupied in Oxford and attack Memphis with the rest of his men, thereby forcing the Union soldiers to withdraw back to Memphis to protect their hold on the city. He hoped to further confound the Yankees by freeing Confederate prisoners and by capturing three important Union generals quartered in the city, including Major General Cadwallader Washburn, the Union army's commander for west Tennessee, and Major General Stephen Hurlbut, the former west Tennessee commander.

With fewer than fifteen hundred men (including his younger brothers, Captain Bill Forrest and Lieutenant Colonel Jesse Forrest), Forrest's band rode through the night and swooped down on unsuspecting Union troops in Memphis just before dawn. As Bill Forrest rode his horse into the lobby of the Gayoso Hotel on Front Street in search of Union general Hurlbut, Lieutenant Colonel Jesse Forrest led a party of men to General Washburn's quarters on Union Avenue near Fourth Street. Washburn was awakened by the sounds of Confederate soldiers breaking through the front door and narrowly managed to escape out a back entrance; he fled down this alley—still dressed in his nightshirt—to the river and the safety of Fort Pickering. Forrest's men seized Washburn's uniform, his sword and some papers before withdrawing south down the Hernando Road, after raising havoc in the city for nearly five hours.

Forrest had Washburn's uniform cleaned and pressed and returned it to him later that day under a flag of truce. Washburn graciously responded by sending to the Confederates "enough gray cloth and buttons and gold lace to make full uniforms for Forrest and his staff." The last word on the raid, though, must belong to Union general Hurlbut, who grumbled one of the wittier remarks of the war: "They removed me from command because I couldn't keep Forrest out of West Tennessee, but Washburn can't keep him out of his own bedroom!"

8. BRINKLEY PLAZA

80 Monroe Avenue

The original Peabody Hotel, built by Colonel Robert C. Brinkley in 1869, stood on this corner until destroyed by fire in 1923. The hotel, named for Brinkley's good friend, Yankee philanthropist George Peabody, was a wedding gift for Brinkley's daughter.

Like the current hotel (rebuilt on Union Avenue), the original Peabody was considered one of the finest in the South. It played host to such notables as Presidents Andrew Johnson and William McKinley and Confederate generals Robert E. Lee, Nathan Bedford Forrest and Jubal Early; plantation owners, professional gamblers and movie stars also frequented the hotel.

The current structure was built in 1924 for the B. Lowenstein & Brothers department store, which moved here from its original Court Square location at Main and Jefferson. After the demise of Lowenstein's in 1967, the building was renovated in 1987 and renamed Brinkley Plaza.

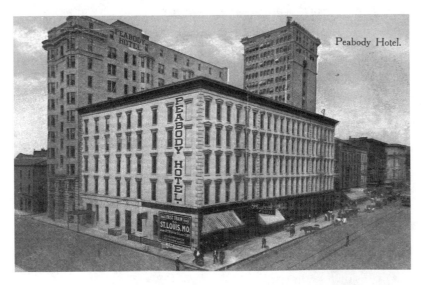

Postcard view of old Peabody Hotel at Main and Madison. *Courtesy of Memphis and Shelby County Room, Memphis Public Library and Information Center.*

9. RESIDENCE INN

110 Monroe Avenue

This lovely art-deco building was built in 1927 as the William Len Hotel. Renovated in the 1970s into an apartment building, it was returned to its original use in 2003 when it became the Residence Inn by Marriott. The lobby retains many original architectural elements, including its distinctive striped marble columns, light fixtures and ornate elevator doors.

William Len Hotel, 1940s. *Courtesy of Memphis and Shelby County Room, Memphis Public Library and Information Center.*

Commerce Title Building. *Courtesy of Memphis and Shelby County Room, Memphis Public Library and Information Center.*

10. COMMERCE TITLE BUILDING

10 South Main Street

The southern half of the neoclassic Commerce Title Building, originally known as the Memphis Trust Company Building, was built in 1904. Ten years later, the north half was added as a mirror image, doubling the building's width; the vertical seam where the two structures were joined is still clearly visible.

Chapter 5

Court Square

This tour—short in length but deep in history—begins in Court Square, then follows around its perimeter clockwise from the north side of the square before ending one block north at Main and Jefferson.

1. COURT SQUARE

North Main Street and Court Avenue

Some say the soul of the city of Memphis resides here in picturesque Court Square. It is said that Davy Crockett and Sam Houston lounged in the park on their visits to town, and it has long been a favorite spot for shoppers and office workers to relax. Although Court Square was one of the four public squares laid out in the original city plan (the others were Market, Auction, and Exchange), it remained marked only by survey stakes for some years after the city's founding. Despite its name, there never really was a court here. Originally, there was a log cabin near the middle of the square, which at various times served as a church and a storehouse and was only occasionally used as a courthouse. The misnomer is not unique: the city's first court faced Market Square; a city market was located at Exchange Square; and no auctions were ever performed in Auction Square.

Court Square, 1900. *Courtesy of Memphis and Shelby County Room, Memphis Public Library and Information Center.*

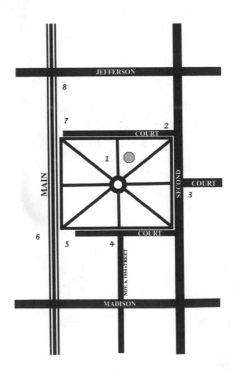

In 1858, a campaign was undertaken to beautify the park that had suffered from the depredations of horses, pigs and other free-roaming livestock. A gated iron fence was installed, along with extensive plantings of magnolias, oaks and shrubbery. A number of statues were placed around the grounds, the most notable of which was a bust of Andrew Jackson by John Frazee, one of the founders of the National Academy of Design. The Jackson bust, the pedestal of which was engraved with Jackson's famous words, "The Union Must Be Preserved," was vandalized during the Civil War; in 1908, the words were re-chiseled into the marble. The bust is now on display inside the Shelby County Courthouse.

By 1865, the square's magnolia trees were the pride of Memphis, so much so that the Union Army placed a guard in the park that spring to keep its own soldiers from climbing the trees and stripping them of the blossoms.

In April of that same year, in a gesture of goodwill toward the citizens of Memphis, the Union army's post band began playing concerts in the park every afternoon at five o'clock. The concerts were so popular that other bands appeared for summer concerts, and in 1870 the city council erected a permanent bandstand. Musical concerts have been a permanent fixture in the square since that time.

In the closing days of the Civil War, a young Thomas Edison worked as a telegraph operator in a Western Union office (now gone) located on the north side of the square. Tinkering as always in his spare time, he invented several devices during his time in Memphis, including an automatic telegraph relay system that for the first time put Washington, D.C., in direct contact with New Orleans; the invention got him fired for insubordination. He is also said to have developed a cockroach shocker, proving that necessity is indeed the mother of invention.

The square has also seen its share of large events. Memphis's Mexican War veterans were welcomed home here in 1847 with a boisterous barbeque complete with oratory, toasts and cannon fire. Grover Cleveland, the first president to come to Memphis while in office, spoke to a large crowd here in 1887, although he was upstaged by the man who introduced him, Judge H.T. Ellet, who slumped

over dead on the bandstand during the address. In the 1940s, it was used for war bond drives, and for many years children would visit Santa here.

The fountain was dedicated in 1876 for the centennial of the United States. It is known as the Hebe Fountain for its beautiful reproduction, at the top, of the statue of Hebe, the goddess of youth, by Italian sculptor Antonio Canova. (The original statue is in the Hermitage in St. Petersburg, Russia.) The water in the fountain was originally ten feet deep and once housed both ducks and baby alligators—although presumably not at the same time. During the city's spectacular Mardi Gras celebrations of 1878, the fountain ran with champagne. The fountain was a gift to the city from fifty private donors whose names are carved in the surrounding wall. One of the more interesting donors, Madam Vincent—believed by some to be the proprietress of a brothel—was a successful and quite respectable independent woman, who operated a popular café and several groceries, one of which was located on the northwest corner of the square.

2. THE TENNESSEE CLUB

130 North Court Avenue

This distinctive building, built for the Tennessee Club in 1890, was designed by architect Edward Terrell in an unusual combination of Victorian Romanesque and Moorish styles. The club was chartered in 1870 by a group of men, many of them former Confederate officers, eager to restore social graces to the city after years of Union occupation. Though organized as a social club for men, the Tennessee Club established a library and art gallery and fostered civic and scientific debates; the building's fourth floor featured a spacious domed ballroom, the scene of many elite gatherings as well as the annual presentation of debutantes.

The Tennessee Club was visited by many of the most prominent people of the time, including two presidents (William H. Taft and Theodore Roosevelt), senators and business tycoons. In 1908,

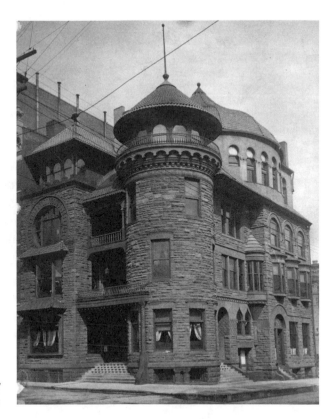

The Tennessee Club. *Courtesy of Memphis and Shelby County Room, Memphis Public Library and Information Center.*

temperance activist Carrie Nation gave a spirited speech condemning the evils of alcohol from the balcony; her speech incited hundreds of supporters to march to Beale Street and smash bar windows. The club was also the center of business and political activity in Memphis; political boss E.H. Crump is said to have conducted much of the city's business from a luxurious meeting room, known now as the Crump Room.

In 1970, the building was purchased and restored by the law firm of Burch, Porter & Johnson. The firm was founded in 1904 by attorney Charles Burch, a former president of the Tennessee Club; it was led for many years by his nephew, Lucius E. Burch Jr., a noted conservationist and civil rights advocate who represented Dr. Martin Luther King Jr. in a successful attempt to lift an injunction prohibiting a march in Memphis.

3. BANK TENNESSEE BUILDING

30 North Second Street

This four-story building, built in 1907, housed the *Commercial Appeal* newspaper from 1907 to 1933. The building featured an electronic sign that kept Memphians up to date with the latest headlines. The newspaper also provided unique play-by-play coverage of Southern League baseball games and the World Series; as the news of an important game came in over the telegraph wire, electric lights traced the plays on a green diamond-shaped sign outside the second floor windows, with the box scores posted below the diamond. At times, as many as seven thousand people filled Court Square to "watch" a game.

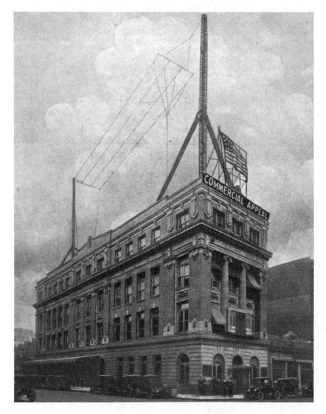

Commercial Appeal building, 1923. Note the large radio towers on the roof. *Courtesy of Memphis and Shelby County Room, Memphis Public Library and Information Center.*

One of the city's first commercial radio stations, WMC, was established on the top floor of the building in 1923. WMC joined the year-old National Broadcasting Company network in 1927; during the devastating Mississippi River flood only a few months later, the station canceled all commercial programming and remained on the air twenty-four hours a day to report on the disaster and relay information between government officials and relief organizations, vividly demonstrating the usefulness of the still-new technology.

In 1933, the *Commercial Appeal* moved to a new location on Union Avenue, and the building became the headquarters of the Welcome Wagon organization, founded in Memphis in 1928 by marketing man Thomas Briggs. Inspired by stories of early Conestoga welcome wagons that would meet and greet westward travelers, Briggs hired hostesses to personally deliver baskets of gifts and coupons supplied by local businesses to new area homeowners. The Welcome Wagon hostess network expanded across the country, becoming one of the first major all-woman companies in the country.

4. November 6, 1934 Street

The street gets its unusual name from the date on which the city voted for a bond issue to allow it to obtain electricity from the publicly operated Tennessee Valley Authority. The TVA was one of the largest of President Franklin Roosevelt's New Deal projects during the Depression, a series of dams on the Tennessee River built to generate inexpensive hydroelectric power for the entire region. Before this time, Memphians had electricity through the privately owned Memphis Power and Light Company; political boss E.H. Crump had been attacking the company ever since he first took office, wanting lower rates and public ownership. In order to plug into the TVA network, the city needed a distribution system approved by the voters; when the bond measure passed by an overwhelming vote, the city celebrated by renaming this narrow alley.

Although the bond issue celebrated was passed in 1934, Memphis did not receive electricity from the TVA until 1939.

5. PORTER BUILDING

10 North Main Street

The Dr. D.T. Porter Building, built in 1895 as the Continental National Bank Building, was the city's first skyscraper and, for many years, was the tallest building in the mid-South. When the building opened, people came from miles around and lined up to pay ten cents for an elevator ride to the roof for the view, which reportedly made many dizzy.

David Tinsley Porter, known as Doctor because he was a pharmacist, was born in Robertson County, Tennessee, grew up in Kentucky and worked for three years as a pharmacist's apprentice in Nashville before moving to Memphis. He never opened a pharmacy in Memphis; instead, he prospered in the wholesale grocery business and after a while held executive positions in banks, insurance companies, cotton and public utilities. In 1879, during the time after the yellow fever epidemics when the city lost its charter, he became president of the taxing district, a position akin to mayor. Porter was responsible for adopting the sewage and water system that cleaned up the city and prevented further outbreaks of yellow fever and cholera.

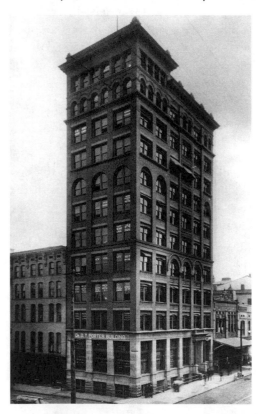

Dr. D.T. Porter Building. *Courtesy of Memphis and Shelby County Room, Memphis Public Library and Information Center.*

Porter died in 1898 and left money in his will for his family to use as a memorial. When the Continental National Bank went into liquidation in 1900, the family purchased the office building and renamed it in his honor.

6. KRESS BUILDING

9 North Main Street

S.H. Kress & Co. was a popular chain of five-and-dime retail stores founded by Pennsylvania businessman Samuel H. Kress in 1896. Samuel Kress, a passionate art collector, took pride in creating beautiful buildings, and the company became known for the fine architecture of its stores. The company's first store (now lost) was in Memphis, farther south on Main Street than this building; between 1896 and 1954, the company built over 250 stores in twenty-nine states. Many of the stores, such as the Main Street store here (the fourth built in Memphis), are now listed on the National Register of Historic Places.

This Memphis Kress store, which opened in 1927, features a colorful and detailed terra cotta façade styled after an Italian Renaissance palazzo. It was renovated in 2005 and is now used by the Marriott Springhill Suites.

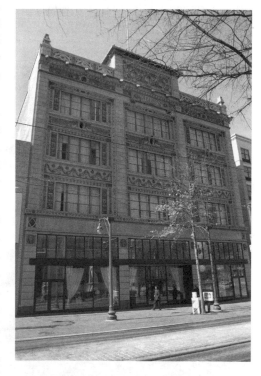

Kress Building. *Courtesy the author.*

7. LINCOLN AMERICAN TOWER

60 North Main Street

The Lincoln American Tower was built in 1924 as the headquarters of Columbia Mutual (later Lincoln American) Insurance Company. On a trip to New York City, Columbia Mutual's president, Lloyd T. Binford, was so impressed with the Woolworth Building that he asked architect Isaac Albert Baum of St. Louis to copy it for Columbia Life. When Baum reminded Binford that the Memphis site had only one-third of the space needed, Binford ordered him to make the building a one-third replica—tower and all.

Today, Binford is most famous—or infamous—as the head of the Memphis Censor Board, a position he held from 1928 to 1955. Binford had an office on the top floor of the building, and from there, he alone decided what movies Memphians would see. Because he had once been robbed while working as a mail clerk on

Lincoln American Tower, 1935.
Courtesy of Memphis and Shelby County Room, Memphis Public Library and Information Center.

a train, he forbade the showing of any westerns that featured train robberies. He hated Charlie Chaplin, so he refused to allow theaters here to show any Chaplin movies. When Ingrid Bergman left her husband and moved in with Italian director Roberto Rossellini, he refused to permit "the public exhibition of a motion picture starring a woman who is universally known to be living in open and notorious adultery." Classics such as *The Wild One* and *Rebel Without a Cause* were banned for promoting juvenile delinquency. Perhaps most disturbingly, he frequently cut or deleted scenes from movies that showed blacks and whites on equal social footing.

His harsh judgments of seemingly harmless films made him a household name across the nation. Publications such as *Colliers* magazine and the *New York Times* denounced Binford and ridiculed Memphis for giving him so much power. *Time* magazine quipped that "Binford has long prided himself on being able to spot a suggestive line even before it is suggested." Binford's efforts were often futile, however; theaters in Mississippi and Arkansas ran the same films, and the promotion of a movie as "Banned in Memphis" almost guaranteed large crowds from the city.

Ill health forced Binford to resign his position in 1956; he died the following year and was buried in Elmwood Cemetery.

8. Lowenstein Building

64–68 North Main Street

Born in Germany, Benedict Lowenstein immigrated to New Orleans as a young man and worked as an itinerant peddler in towns along the Mississippi River. By 1855, he settled in Memphis and opened a store near the present-day Orpheum Theater. The business flourished, and he soon brought over three of his brothers from Europe. B. Lowenstein and Brothers became one of the largest dry-goods stores and wholesale suppliers in Memphis. Many peddlers and small-town store owners in the region received their merchandise from B. Lowenstein and Brothers, and it remained one of the city's major department stores well into the twentieth century.

Lowenstein Building. *Courtesy the author.*

After Benedict died, his brother Elias took over the business and became a respected leader of the local business community.

This beautiful building, with terra cotta angels and a façade of brick, limestone and cast-iron, was built in 1886 to house Lowenstein's flagship store. It replaced a notorious gambling hall on the corner of Jefferson and Main, known as the Senate Gambling House.

In the 1920s, B. Lowenstein and Company moved to a new location at 80 Monroe Avenue. The Rhodes-Jennings Furniture Company occupied the Main Street building until 1980. The restored Lowenstein building reopened with mixed residential and commercial space in 2009.

Chapter 6

Civic Memphis

M emphis received its first true civic center with the completion of the Shelby County Courthouse in 1909 and the adjacent police and fire department headquarters in 1911. Prior to this, the mayor and city council occupied offices in the original Cotton Exchange Building (built in 1847, now lost), a cavernous structure on Front Street and Poplar Avenue at the current site of the convention center, while the courthouse was next door in the old Overton Hotel at Poplar and Main.

This short tour visits the city's government buildings, beginning with the Crump Building at Adams and Main, then moving east on Adams to the courthouse and the former criminal courts building and ending at the modern Civic Center Plaza.

I. CRUMP BUILDING

110 Adams Avenue

This slender building may look somewhat out of place on the edge of muscular, mid-century modern Civic Center Plaza, but it is fitting that it remains: for over thirty years, this office building was the center of the city's political universe. Built in 1901 as the North Memphis Savings Bank, the building became the home of the E.H. Crump Insurance Company in 1920, and it was from here that E.H.

Crump Building. *Courtesy the author.*

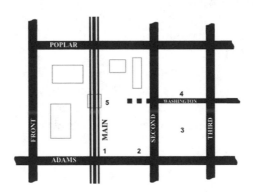

"Boss" Crump controlled the city and even the state through his political machine.

Crump came to Memphis in 1893 at age eighteen from Holly Springs, Mississippi, with twenty-five cents in his pocket. He worked his way up the ladder in a succession of jobs, married into a prominent family and turned his eyes to politics. After being elected to minor city offices, he was elected as a reform mayor at age thirty-five; he

soon expanded into state politics and for decades ruled Memphis and Tennessee politics with a benevolent but despotic grip.

Crump's legacy remains controversial in Memphis. Although elected as a reformer, Crump financed his political organization by various forms of protection money from bootleggers, gamblers and organized crime. When Tennessee voted to outlaw the sale of liquor in 1909—a measure not popular in Memphis—Crump responded by imposing only a token fine of fifty dollars on saloonkeepers; lines of offenders at the courthouse on Monday mornings stretched around the block, but the saloons stayed open. In 1916, when the state legislature finally enacted a law aimed at ousting Crump from office for nonenforcement of state law, Crump resigned but continued to control the action from behind the scenes.

Crump's influence stemmed from his adept use of what were at the time two politically weak minority groups in Tennessee: blacks and Republicans. Unlike most Southern Democrats of his era, Crump was not opposed to blacks voting, and a symbiotic relationship developed in which blacks aided Crump and Crump aided them. Crump also skillfully manipulated Republicans, who were numerically weak in the western two-thirds of the state but dominated politics in east Tennessee. Frequently they found it necessary to ally themselves with Crump in order to accomplish any of their goals, and those alliances virtually guaranteed majorities for Crump's hand-picked candidates.

Under Crump's rule, criticism and public opposition were not tolerated. A letter to the editor critical of the administration often resulted in the loss of a citizen's job; journalists were sometimes beaten for getting too close to stories on such issues as election fraud. Crump's machine organization especially sought to intimidate black leadership as well as union organizers. He controlled patronage jobs, empowered his friends and ripped his enemies with verbal invective (he famously derided one opponent as a "pet coon" and called another a donkey and a vulture who had "no more right to public office than a skunk has to be foreman in a perfume factory").

Nonetheless, under Crump's absolute rule, city services worked. Garbage was picked up daily, streets were cleaned, fires put out and criminals arrested. He reduced property taxes a few pennies a year

and gave the city good parks, good schools and good libraries. In 1930, Crump instituted the Memphis City Beautiful Commission, the nation's first urban beautification commission, and the city was four times voted Nation's Cleanest City. As an article in Time Magazine noted in 1946, "In his 37 years of benign if iron despotism, [Crump] has given Memphis citizens almost everything but the right to vote for a candidate of their own choosing."

Crump died in 1954, just three months after Elvis Presley's debut on the airwaves. He was buried in Elmwood Cemetery.

2. FIRE MUSEUM AND CENTRAL POLICE STATION

118 and 130 Adams Avenue

Fire Station Number One (now the Fire Museum of Memphis) and the former Central Police Station next door were built in 1910 and 1911, respectively, and owe much of the inspiration behind

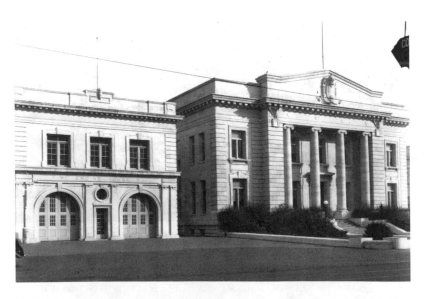

Fire Station Number One and Central Police Station, 1930s. *Courtesy of Memphis and Shelby County Room, Memphis Public Library and Information Center.*

their neoclassical style to the Shelby County Courthouse on the east side of Second Street. Mayor E.H. Crump, a former fire and police commissioner, was a champion of both the fire and police departments, and the buildings, constructed soon after completion of the courthouse, show his intention to elevate the status of the departments and build, for the first time in the city's history, a group of monumental, inspiring public buildings.

Memphis had its first professional firefighters in 1866, but there had been a volunteer firehouse here on Adams Avenue since at least 1855; the original brick pavement can still be seen in front of the building.

The Fire Museum contains numerous exhibits on fire safety and the history of firefighting in Memphis, including uniforms, helmets and antique firefighting equipment. Several historic fire engines that were used by the Memphis Fire Department are also on display, including a horse-drawn steam engine named the E.H. Crump and the city's first motorized fire engine from 1912.

The former Central Police Station is built on the site of an older police headquarters building. Behind the old station in the 1890s was a rock pile, where offenders were put to work making little rocks out of big ones under the watchful eyes of Memphis's finest.

3. SHELBY COUNTY COURTHOUSE

Adams Avenue between Second and Third Streets

The Shelby County Courthouse, built between 1906 and 1909, was the first monumental work of architecture designed for local government. (Prior to construction of the courthouse, city and county courts were in a log cabin on the edge of Market Square and then in rented space in a hotel.) The neoclassical structure features six large, seated figures by Scottish-born sculptor John Massey Rhind, each carved from a single block of Tennessee marble. The figures represent Wisdom, Justice, Liberty, Authority, Peace and Prosperity.

Pediments on the Washington Street (north) façade are decorated with other allegorical figures representing Prudence, Courage, Integrity, Learning, Mercy and Temperance. For those with a special

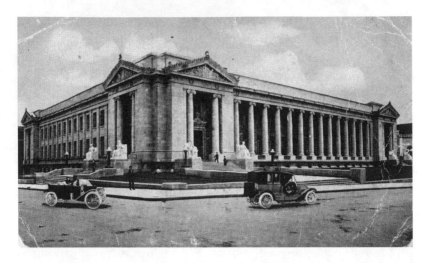

Shelby County Courthouse, 1912. *Courtesy of Memphis and Shelby County Room, Memphis Public Library and Information Center.*

interest in symbolism, it is interesting to note that over the years two of these figures have lost their heads: Integrity (twice) and Learning. Decorations on other pediments depict the origins of law.

Until 1966, the building housed not only state and local courts but also the mayor's offices and the legislative chambers of both the City of Memphis and Shelby County.

4. SHELBY COUNTY ARCHIVES—HALL OF RECORDS

Washington Avenue between Second and Third Streets

Built in 1924, this building housed the Shelby County criminal courts and jail until 1982. Its Renaissance design borrows elements from the Church of Santa Maria Della Salute in Venice.

In 1933, the entire third floor of the jail was cleared to house a single inmate, George Francis Barnes Jr., better known as Machine Gun Kelly, the Depression-era gangster. Kelly, a Memphis native, was designated by the FBI as the nation's first Public Enemy

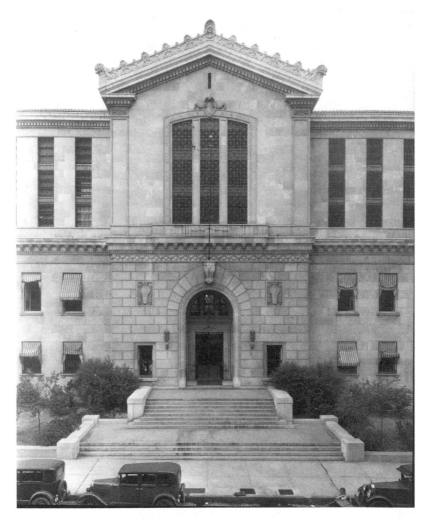

Shelby County Criminal Courts Building, 1930s. *Courtesy of Memphis and Shelby County Room, Memphis Public Library and Information Center.*

Number One for his role in bank robberies, bootlegging and the kidnapping of millionaire Oklahoma oilman Charles Urschel. Kelly was captured in Memphis and held here before standing trial in Oklahoma City; he was sentenced to life imprisonment and became one of the first inmates of Alcatraz Prison in San Francisco.

In 1968, the third floor of the jail was once again cleared for a single prisoner, James Earl Ray, the killer of Martin Luther King Jr. Ray resided here for over nine months under tight security until being transferred to the Brushy Mountain State Penitentiary to serve his life sentence; some local residents still refer to this building by its nickname, the James Earl Ray Mansion.

5. CIVIC CENTER PLAZA

North Main Street between Adams and Poplar Avenues

In 1962, the area of Main Street between Adams and Poplar Avenues was bulldozed for the construction of Civic Center Plaza, one of the first of many great urban renewal projects intended to revive and revitalize downtown.

The original plan called for a pedestrian plaza surrounded by a city hall, federal and state office buildings, parking facilities, a fountain and reflecting pool with a view open to the riverfront and a 350-foot observation tower at the corner of Front Street and Washington Avenue. All but the tower were built, although the fountains now shoot directly from the pavement and the reflecting pool has since been replaced by the clock tower and the Main Street trolley line.

Across the plaza from the 1901 Crump Building is Memphis City Hall, designed in 1966. The piers that rise from the plaza are faced on two sides with black marble and two sides with white, with obvious symbolic intentions; originally the marble didn't adhere to the piers very well, earning the building the nickname of Marble Falls. Inside, the lobby contains portraits of the mayors of Memphis.

Counterclockwise around the plaza from the north of city hall are a flag court, featuring some of the flags of countries honored in the annual Memphis in May festival, the city's largest festival; the Clifford Davis Federal Building (completed in 1963); the Donnelley J. Hill State Office Building (1965); and the Shelby County Administration Building (1969).

Chapter 7

Second and Third Streets

The area between Second and Third Streets north of Adams Avenue contains many of the city's oldest churches as well as other sites of interest.

The city's first resident preacher was the Reverend Harry Lawrence, a Methodist minister as well as a slave. He preached to street-corner crowds of whites and blacks beginning in 1822, only three years after the founding of the city. In the first bare-knuckle days of the city's existence, when Memphis was populated by frontier merchants, gamblers and visiting flatboatmen thirsty for whiskey and spoiling for a fight, the town had a decidedly nonreligious air; one early history of Memphis noted that "the earliest settlers here, we regret to say, had little time, if even inclination, to devote to spiritual affairs." But as more settlers arrived, religion and respectability grew. The second half of the nineteenth century saw the construction of churches for several of the major denominations near Poplar Avenue and Second Streets, the site of the city's first church—First Methodist. Two other important early churches, Beale Street Baptist and Clayborn Temple, are included in the Beale Street chapter.

This chapter also includes the Eugene Magevney House, the oldest existing house in the city, and the Depression-era Works Projects Administration housing project Lauderdale Courts (now Uptown Square), the early Memphis home of young Elvis Presley.

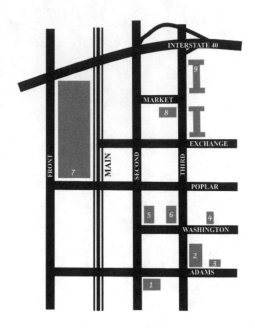

1. Calvary Episcopal Church

102 North Second Street

Episcopal services were first held on a flatboat on the river beginning in 1832, but ten years later the congregation purchased this lot on the corner of Second and Adams. Construction began in 1843 on a design by the congregation's minister, Rev. Philip Alston, also an amateur architect. The roof collapsed four years later—Alston was, after all, an amateur—but other than the addition of a tower in 1848 and an addition to the east in 1881, the steep-pitched building remains Alston's basic design. It is the oldest public building in Memphis.

The building was once covered with a stucco veneer to resemble stone, which was removed in 1961 to expose the handmade clay bricks seen today. A remodeling of the nave in the 1880s removed Alston's original flat ceiling and replaced it with the present open-timber roof, giving the interior the feel of an English parish chapel.

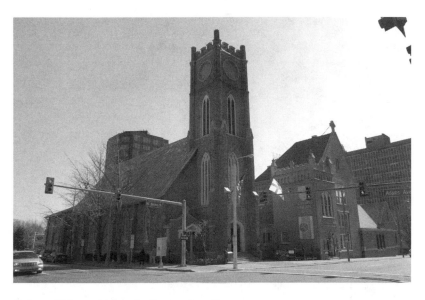

Calvary Episcopal Church. *Courtesy the author.*

Local lore tells of a time in the Civil War when General Sherman, then commander of Yankee-occupied Memphis, attended services here one Sunday. The minister warned that the ritual included a prayer for the president, which could create an awkward situation. "Whom do you regard as your president?" asked Sherman. "We look upon Mr. Davis as our President," was the reply. "Very well; pray for Jeff Davis if you wish. It will take a great deal of praying to save him." The minister inquired whether he would also be compelled to pray for Abraham Lincoln. "No," Sherman answered. "He's a good man, and don't need your prayers."

2. St. Peter's Church

190 Adams Avenue

St. Peter's was founded in 1840 and is the oldest Catholic congregation in Memphis. The purchase price of the lot here on the corner of Adams and Third—five hundred dollars—was raised by a

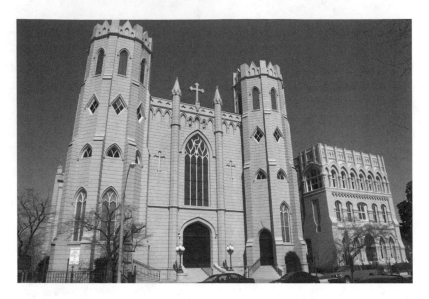

St. Peter's Church. *Courtesy the author.*

number of Protestant churches in Memphis as a gift to the Catholic community. The original structure was a simple brick building, thirty by seventy feet. Construction of the present church building began in 1852 and was completed in 1855. So as not to disrupt church functions, the new structure was built around the intact older building; once completed, the original building was dismantled and carried out the front door piece by piece.

The architect was Patrick C. Keely, who, as a sort of in-house architect for the Roman Catholic Church, designed nearly seven hundred churches across the nation in the nineteenth century. His polished, professional, imposing design here made St. Peter's one of the most stunning church buildings in the city. Of special note are the soaring Gothic interior and the stained glass windows. The window over the entrance is dedicated to parishioners who served in World War I. Made in Munich, Germany, and installed in 1924, the window depicts a kneeling soldier and sailor, an array of Dominican saints and a dog holding a lighted torch in its mouth. Legend has it that the saints all bear a resemblance to the pastor of the church at the time the window was installed.

In 1934, St. Peter's became the first church in Memphis to be air conditioned. During the installation of duct work, the remains of three priests were discovered in iron caskets under the main altar; one died of cholera and the others of yellow fever after serving the city through its epidemics.

3. Eugene Magevney House

198 Adams Avenue

This is the oldest home still standing in Memphis, built in 1833 by Eugene Magevney, an immigrant from Ireland. It is a good example of the kind of modest, middle-class homes that were common in this part of the city in the middle of the nineteenth century—a simple structure with a large kitchen garden in the rear where the family would grow their own vegetables and herbs.

Magevney studied to be a priest in Ireland but changed his mind and became a schoolteacher instead. In 1828, he immigrated to the

Eugene Magevney House. *Courtesy the author.*

United States and settled in Memphis in 1833. Magevney ran one of the city's first private schools and became a community leader; he served as an alderman and, in 1848, led the fight to establish the city's first public schools.

In 1839, the first Catholic Mass was celebrated here in this house, where the first marriage (his own) and the first baptism (his daughter, Mary) were also celebrated. Magevney was also one of those responsible for the founding of St. Peter's Catholic Church, located next door.

The house was owned by the Magevney family until the 1940s, when it was donated to the City. It is expected to be open for tours in 2011.

4. Trinity Lutheran Church

210 Washington Avenue

Social and political upheavals in Germany in the early 1800s drew a wave of German immigrants to the United States and the Mississippi Valley, especially to the area around St. Louis. By the 1840s, German immigrants were also figuring prominently in Memphis, and in 1855, the Missouri Synod of the German Lutheran Church sent a missionary, John Beyer, to Memphis to conduct German language services. Services were held initially in the First Presbyterian Church at Third and Poplar and later in several rented spaces on Main Street.

In 1871, the congregation purchased this lot on Washington Avenue and opened the first story of the current two-story building in 1874. Completion of the building was delayed by the yellow fever plagues of the 1870s, which greatly reduced the church's membership. Church records list 99 who died; many more resettled in St. Louis, and the church's membership dwindled from 600 to 140. Nonetheless, the city's German population soon rebounded, and the church's second-floor sanctuary was opened in 1888. Services were conducted in German until 1910; all use of German language in church records was discontinued by the time of World War I.

The interior of the sanctuary retains much of its original look today, with stained-glass windows from Germany and an altar hand

carved in Dresden. The exterior, originally of distinctive dark red brick with white limestone trim, was covered with a regrettable permastone veneer in 1950.

5. FIRST UNITED METHODIST CHURCH

204 North Second Street

In 1832, the Methodists built the first religious building in Memphis, a log meeting house here at the corner of Poplar and Second. The meeting house had two doors for men and women to enter separately and benches made by laying planks across blocks. It is said that the crude benches often gave way under the religious zeal of the congregation, sending folks sprawling to the floor in their Sunday finest.

First United Methodist Church. *Courtesy of Memphis and Shelby County Room, Memphis Public Library and Information Center.*

115

By 1843, the Methodists had outgrown the log structure and moved it to the back of the lot to begin construction of a larger church; this in turn was replaced by a third structure in 1887, the first all-stone church in Memphis, made of granite and limestone from Alabama and Arkansas. Completed in 1893, the church's Second Street entrance featured large double doors under a central arch and, to the right of the doors, a recessed tower with a clock and a tall, thin steeple. The church burned to the ground in one of the most spectacular fires in the city's history, a three-alarm blaze in the early morning hours of October 6, 2006, that collapsed the roof and toppled the steeple. Embers spread on the wind to Court Square four blocks away, sparking fires there that destroyed one building and damaged two others, including the twenty-two-story Lincoln American Tower. The heat from the fire was so great it broke windows out of the Shelby County Election Commission across the street. In 2009, services resumed in the renovated Sunday school building next door that was damaged but not destroyed by the fire. A new Gothic-style church, similar in appearance to the old structure, is expected to be completed in 2011.

6. FIRST PRESBYTERIAN CHURCH

166 Poplar Avenue

The First Presbyterian Church was organized in 1828. It was the second organized congregation in Memphis after the Methodists. In 1832, the city deeded to the congregation this corner lot, and ever since that time the Methodists and Presbyterians have shared the block of Poplar Avenue between Second and Third Streets.

A small brick structure was completed in 1834 with money raised by a bazaar held by the ladies of the congregation in a nearby saloon. It was replaced by a larger building in 1854. The 1854 church was seized by Union troops during the Civil War, who nailed an American flag over the door; the minister at the time, refusing to pass under the Yankee flag, got a ladder and entered the church through a back window. Later, in 1873, during the first of the devastating epidemics of yellow fever to hit the city that decade, the

First Presbyterian Church in the 1890s. *Courtesy of Memphis and Shelby County Room, Memphis Public Library and Information Center.*

same minister, who was administering to the sick, caught the fever and died. The roof of the sanctuary collapsed during his funeral service; lives were spared only because the funeral was being held outdoors to prevent further infection.

The 1854 church was destroyed by fire and was replaced in 1884 by the church we see today. It originally had a wooden spire, one of the tallest and most graceful in the city. The spire has since been removed and the base reshaped into the squat Romanesque brick belfry. The interior, though extensively remodeled over the years, retains the intricate, geometric moldings of architect Edward Culliatt Jones's ceiling design.

7. MEMPHIS COOK CONVENTION CENTER– CANNON CENTER FOR THE PERFORMING ARTS

255 North Main Street

The current building opened in 2003 and is home to Memphis's convention facilities and the Cannon Center for the Performing Arts, a twenty-one-hundred-seat facility hosting the Memphis Symphony Orchestra, touring ballet, opera and theatrical productions as well as comedians and pop and jazz artists.

The Cannon center replaced the historic Ellis Auditorium, a giant Italian Renaissance structure that housed two separate halls with a movable stage in between. John Philip Sousa inaugurated the Ellis Auditorium in 1924, and the auditorium soon came to be one of the most influential buildings in the history of Memphis music. In the 1920s and '30s, it was used by RCA Victor Records and other national record labels for field recordings of local blues artists. During the 1940s and '50s, radio station WDIA (discussed in the Main Street chapter) hosted its annual holiday season Goodwill Revues at the auditorium, featuring such stars as B.B. King, Bobby "Blue" Bland, Ray Charles, Clara Ward and Phineas Newborn Sr.

Also influential were the monthly All Night Gospel Sings headlined by Memphis-based gospel group the Blackwood Brothers. Although all-day and all-night gospel sings had been popular across the South since the 1920s, in the late 1940s and '50s gospel quartets such as the Blackwood Brothers and the Statesmen began to promote an entertainment-oriented, show-business style approach to Christian music on a large scale.

The Blackwood Brothers were the first gospel group to sell over a million records; the first to sign a recording contract with a major record label (RCA); and the first to get nationwide television exposure. They performed with a high degree of showmanship; the All Night Sings at the auditorium were often raucous, rambunctious affairs closely akin to a modern secular rock concert. Johnny Cash was an admirer of the Blackwood Brothers and attended All Night Sings as money allowed after moving to Memphis in 1954;

nineteen-year-old Elvis Presley also regularly attended with Dixie Locke, his girlfriend from Lauderdale Courts, and sometimes served as an usher.

On February 6, 1955, Elvis led his own band in a show at Ellis Auditorium, the first of several memorable performances on that stage; it was on that night that Elvis first met his future manager, Colonel Tom Parker, at Palumbo's Restaurant (now lost), across the street from the auditorium. Elvis played Ellis Auditorium twice more in 1955 and headlined there in May 1956. His last performance at the auditorium was on February 25, 1961.

8. St. Mary's Catholic Church

155 Market Avenue

St. Mary's was organized in 1862 to serve the German Catholic population of Memphis, who were uncomfortable at the Irish-oriented St. Peter's four blocks south. The cornerstone of the church was laid with the help of the occupying Union army; the very fact that construction of a major church would start in the midst of the Civil War is a good indication of the city's relative prosperity during the war.

The church was dedicated in 1870, but work continued until 1874. A steeple was finally completed in 1901 but was removed shortly thereafter for structural reasons.

The interior was modeled after the interior of St. Peter's, though it is smaller and more brightly painted. The altar is carved from wood shipped from Germany; the pews and a graceful choir loft, shaped like the bow of a ship, were hand carved by itinerant Franciscan monks, skilled in woodworking, who traveled from site to site making church furnishings.

9. LAUDERDALE COURTS

Third Street between Exchange and Winchester Avenues

Lauderdale Courts—now known as Uptown Square—was a Depression-era WPA housing project, one of the first in the country. Constructed in 1938 during the days of segregation, Lauderdale Courts was a whites-only complex; another housing project, Dixie Homes (now lost), farther east on Poplar Avenue, was built simultaneously for blacks. Public housing projects today can rarely be pointed to with pride, but the Memphis Housing Authority and chief architect J. Frazer Smith created an environment that lived up to the ideals of the New Deal. The housing units were constructed around a center axis with a number of intimate courtyards that created a sense of community; from its very first days, Lauderdale Courts radiated an atmosphere of optimism. The 433 apartments featured such amenities as parquet floors and modern kitchens. With a family-income cap at $2,500 per year, Lauderdale Courts gave many of its residents their first home ever with indoor plumbing.

This was true for Lauderdale Courts's most famous resident, Elvis. The Presleys lived here from 1949 to 1952, while Elvis was in high school. They had arrived in Memphis from Tupelo, Mississippi, a year earlier and lived in downtown boarding houses (at 370 Washington Avenue and 572 Poplar Avenue, neither of which remains), before applying for a unit here. Lauderdale Courts was a respite for the family, a place to settle down for a while and put down some roots. For the first time in his life, Elvis had his own bedroom. Gladys, Elvis's mother, made friends with her neighbors and talked a neighbor's son, Jessie Lee Desson, into giving guitar lessons for Elvis. Jessie was nervous about this prospect, concerned that his friends—Dorsey and Johnny Burnette, musicians who were also amateur boxers—would make fun of Elvis.

Desson and the Burnettes were also friends with another musician at the courts, Johnny Black. (Johnny Black, incidentally, was the younger brother of Bill Black, who later became Elvis's bassist.) The

Second and Third Streets

Lauderdale Courts. *Courtesy the author.*

Burnettes, Black, Desson and Elvis would often play music in the basement or the mall area of the complex. Elvis was shy and was not usually the one gathering most of the attention. In fact, he became quite embarrassed when some girls from Lauderdale Courts caught him practicing his guitar in the basement.

Elvis had three girlfriends from Lauderdale Courts: Betty McMahon; Billie Wardlaw, who claimed he was a good kisser when playing spin the bottle; and his high school prom date, Regis Wilson.

In 1952, the Presleys were asked to leave the courts because they had too much income to qualify for public housing. The combined family income that year was just over $4,000. They remained in the neighborhood, moving to nearby Saffarans Avenue for a few months before finding rooms in a boarding house (now lost) across the street from Lauderdale Courts on Alabama Street.

The entrance to the Presley apartment is at 185 Winchester Avenue. The apartment itself is best seen from Third Street; the Presley apartment occupies the third and fourth windows on the

first floor to the left of the entrance for 280 Third Street. Elvis's bedroom window has a small white sticker in the lower corner. The apartment has been restored to its early 1950s appearance and may be visited or rented for the night by arrangement with the Uptown Square leasing office.

Chapter 8

Victorian Village

Adams Avenue was once one of the most fashionable streets in Memphis, where many of the city's elite built their grand mansions. Today, only a few remain in this historic district known as Victorian Village—an area bounded by Poplar Avenue, Manassas Street, Madison Avenue and Danny Thomas Boulevard—but it is not hard to imagine this tree-lined neighborhood as it looked at the turn of the twentieth century.

This tour starts at the Mallory-Neely House on Adams and proceeds east along the row of grand residences that are the core of Victorian Village. One block to the north along Orleans Street is Collins Chapel, the oldest black congregation in Memphis, and one block farther north is the historic St. Mary's Episcopal Cathedral. The 1890 Lowenstein House can be found on Jefferson Avenue one block south of Adams.

1. MALLORY-NEELY HOUSE

652 Adams Avenue

This house began as a relatively modest one-story structure, built in 1852 by Isaac Kirtland, who was president of an insurance company. In 1864, it was purchased by cotton factor Benjamin Babb, who added a second story before selling it to James Neely in 1883.

Neely, a produce dealer and cotton factor, restyled the house in the 1890s, adding the third story and heightening the central tower to get a view of the river. Part of Neely's modernization of the house involved the use of window screens—believed to be the first in Memphis—and the installation of air channels into the walls to provide an early kind of air conditioning. The High Victorian-style interior features ceiling stenciling, ornamental plasterwork, faux-grained woodwork, heavily carved mantelpieces and stained glass windows from the family's visit to the Columbian Exposition in Chicago in 1893.

After James Neely's death in 1901, the twenty-five room house passed to his wife and children. The three sons sold their interests to sister Frances, called Daisy, who had married cotton factor Barton Lee Mallory. Miss Daisy lived in the house until her death in 1969 at age ninety-eight. She made remarkably few changes to the house—keeping even the gas lights in the drawing room and music room—making it a unique time capsule of Victorian life. Miss Daisy's heirs gave the house

Mallory-Neely House.
*Courtesy of Memphis
and Shelby County Room,
Memphis Public Library and
Information Center.*

and its entire contents to the Daughters, Sons and Children of the American Revolution to be preserved as a museum; it is now owned by the City of Memphis Division of Park Services and is slated to reopen for public tours in 2011.

2. Massey House

664 Adams Avenue

This one-story, neoclassic house—the oldest in the neighborhood—gives the best sense of early Adams Avenue before the High Victorian era. Built between 1844 and 1849, it features a wide central hall with floor-length windows. It was originally the residence of lawyer Benjamin Massey; for a time after the Civil War, it was home to James Maydwell and his wife, Sophia Harsson Maydwell, who frequently entertained Jefferson Davis and his wife, Varina, at the house.

3. WOODRUFF-FONTAINE HOUSE

680 Adams Avenue

One of the most elegant of the city's old Victorian houses, the Woodruff-Fontaine house has a steep mansard roof, showing a French influence. Unlike many of the neighboring residences, the house was built all at one time, giving it a true unity of design. It was commissioned in 1870 by Amos Woodruff, a New Jersey carriage maker who had come to Memphis twenty-five years earlier and had risen to become president of two banks, a railroad company, a cotton compress and a lumber company as well as an alderman and president of the city council. The architects chosen were Edward Culliatt Jones and his partner, Mathias Baldwin, two of the city's leading architects of the day.

Woodruff-Fontaine House. *Courtesy of Memphis and Shelby County Room, Memphis Public Library and Information Center.*

The house was completed in 1871, just months before the wedding of Amos Woodruff's daughter, Mary Louise, called Mollie. Mollie and her husband resided in the house with her parents in a suite of rooms on the second floor. In a room known as the Rose Room in the rear of the house, Mollie's first child, a son, died a few days after his birth; several months later, Mollie's husband died in the same room after catching pneumonia on a boating trip. The widowed Mollie

continued to live in the house until she remarried in 1873. Mollie lived until 1932 but not without further tragedy—her only child with her second husband died the day of its birth in 1885. Her ghost is said to have returned to the house and inhabits the Rose Room.

In 1883, Amos Woodruff sold the house to Noland Fontaine, president of Hill, Fontaine & Company, at the time the world's third largest cotton company. The Fontaine family lived here for the next forty-six years. Noland and his wife, Virginia, were famous for their lavish dinner and garden parties; they celebrated the opening of the Great Memphis Bridge in 1892 with a reception at the house for more than two thousand guests, among them five state governors. John Philip Sousa is said to have conducted the orchestra at another of their garden soirees, and President Grover Cleveland was entertained here during his Memphis visit in 1887.

In 1930, the house was purchased by Miss Rosa Lee for the expansion of her art academy next door; the carriage house behind the property—originally two separate stables joined together by Miss Rosa—was converted into a theater. The art school moved to Overton Park in 1959, and the house remained vacant until 1961 when the Association for Preservation of Tennessee Antiquities saved the mansion through a public fund drive. It is now open for tours and is well worth a visit.

4. Mollie Fontaine Taylor House

679 Adams Avenue

Noland Fontaine, of the Woodruff-Fontaine House across the street, built this house as a wedding gift for his daughter, Mollie, when she married Dr. William Taylor. The house was completed in 1890; Mollie Taylor lived here until her death in 1936.

The exterior of the house has a number of different decorative elements, including Chinese, Moorish and late baroque influences. As author Perre Magness wrote in her book *Good Abode: Nineteenth Century Architecture in Memphis and Shelby County, Tennessee*, the house "is a fine example of the late Victorian idea that if one kind of decoration is good, two or three kinds will be better." It has been

Mollie Fontaine
Taylor House.
*Courtesy of Memphis
and Shelby County
Room, Memphis
Public Library and
Information Center.*

restored and is currently a lounge and piano bar. Like many of
the historic homes of Victorian Village, it is said to be haunted;
the ghost of Mollie Fontaine (not to be confused with the ghost of
Mollie Woodruff across the street) often plays tricks on patrons of
the lounge but is generally a fun-loving soul. By tradition, the first
drink of the night is hoisted with a hearty "Cheers to Mollie!" to
placate her spirit and keep the mischief at a minimum.

5. James Lee House

690 Adams Avenue

Like the Mallory-Neely house down the street, this house began
as a much more modest structure; in this case, a relatively plain
two-story farm house built in 1848. William Harsson, a native of

James Lee House. *Courtesy of Memphis and Shelby County Room, Memphis Public Library and Information Center.*

Baltimore, was the original owner. One of Harsson's daughters, Sophia, married James Maydwell and lived two doors down at 664 Adams (known today as the Massey House). Another of Harsson's daughters, Laura, married Charles Wesley Goyer. In 1852, Goyer bought the house from his father-in-law; the Goyer family would live here until 1890.

Goyer was a sugar and molasses importer who grew so rich, it is said, that he founded Union Planters Bank in order to have some place to keep his money. When it was necessary in 1871 to expand the house (the Goyers would eventually have ten children), Goyer hired architects Edward Culliatt Jones and Mathias Baldwin after seeing their work on the Woodruff house next door. Perhaps envious of his neighbor's tower, Goyer had Jones and Baldwin design a tower for his house; a third floor was also added, and the front façade dressed in a unifying layer of stone. One noteworthy aspect of the new design is the importance of appearances; the rich effect of the

front sandstone façade gives way to stucco or bare brick on the less important side and rear faces of the house.

In 1890 the house was sold to James Lee Jr., son of steamboat magnate James Lee. James Jr. moved here from 239 Adams with his family of ten children. The bell from the riverboat *James Lee* hangs near the side door of the house along Orleans Street.

The house ultimately became the property of his daughter, Rosa Lee. Rosa became interested in art through her friend Florence McIntyre, who lived in the Pillow-McIntyre House across the street. In 1922, Rosa donated her family's home to the city for use as the city's first art school, the James Lee Memorial Academy of Arts, with Florence McIntyre as its director; Rosa Lee added the Woodruff-Fontaine House to the gift several years later. The house has been vacant since the school moved to Overton Park in 1959; it is currently being restored.

6. Collins Chapel CME Church

678 Washington Avenue

Collins Chapel is the oldest African American religious congregation in Memphis, tracing its roots to 1841, when parishioners of First United Methodist Church at Second Street and Poplar Avenue invited a group of slaves to join Sunday services. Four years later, the number of blacks worshipping at the church grew to over five hundred, and the church deeded its own basement to the black congregation for separate services. By 1859, having outgrown the church basement, the congregation purchased this lot; services were held outdoors until completion of the chapel in 1860. It is named for the Reverend J.T.C. Collins, the congregation's white minister.

Over the years, Collins Chapel congregations have included civil rights pioneer Ida B. Wells and members of the Memphis Red Sox, the city's Negro League baseball team. W.C. Handy also attended services here, although it is said that the Father of the Blues—or the devil's music, in the eyes of many church members—was not warmly welcomed.

7. ST. MARY'S EPISCOPAL CATHEDRAL

692 Poplar Avenue

St. Mary's originated as a mission church, organized by Calvary Episcopal Church in 1857. It became the cathedral church of the Episcopal Diocese of Tennessee—later the West Tennessee Diocese—in 1871.

At the time of its founding, the surrounding area was semirural at the eastern edge of the city. The original church was a small, wooden Gothic structure and officially dedicated in 1858. St. Mary's School for Girls was opened here in 1873, led by a group of Episcopal nuns from the recently formed Sisterhood of St. Mary.

In the yellow fever epidemic of 1878, which ultimately claimed the lives of nearly a quarter of the city's population, the cathedral was turned into an infirmary; the nuns' superior, Sister Constance,

St. Mary's Episcopal Cathedral. *Courtesy of Memphis and Shelby County Room, Memphis Public Library and Information Center.*

traveling at the time the fever hit, returned to Memphis as soon as she heard the news. Warned that the church was in the infected zone, Sister Constance nonetheless proceeded directly to the church, where she and other nuns of St. Mary's cared for the sick in the infirmary, sent orphaned children out of the city and took soup and medicine on house calls. Within a month, Constance, three other Episcopal nuns and two Episcopal priests perished. The cathedral's high altar, dedicated in 1879, memorializes their sacrifice.

Construction of the present English Gothic-revival structure began in 1898 and was completed in 1926. The small chapel on the east side of the cathedral, built in the 1880s, has one of the few wooden Gothic interiors from the nineteenth century remaining in the city.

8. PILLOW-MCINTYRE HOUSE

367 Adams Avenue

In contrast to the ornate Victorian mansions elsewhere on the street, the Pillow-McIntyre house is a simpler, more restrained Greek-revival style house, typical of the antebellum South. It was built in 1852 by C.G. Richardson; after the Civil War, it was purchased by Confederate general Gideon Johnson Pillow. After Pillow's death by yellow fever in 1878, the house was sold to Peter McIntyre, founder of the first sugar refinery in Memphis. McIntyre was married to Ella Goyer, who grew up in what is now known as the James Lee House across the street. Their daughter, Florence McIntyre, inherited the house, and it became in 1942 the home of the Memphis Art Association's Free School, founded in 1922 by Rosa Lee.

Florence McIntyre, known as the First Lady of Memphis Art, was a painter who had studied under William Merritt Chase and was the first director of the Brooks Museum, the city's first art museum. She published numerous articles and papers in local and national publications and was active in the preservation and restoration of her house as well as the Woodruff-Fontaine and James Lee houses.

Pillow-McIntyre House. *Courtesy of Memphis and Shelby County Room, Memphis Public Library and Information Center.*

9. LOWENSTEIN HOUSE

756 Jefferson Avenue

Born in Darmstadt, Germany, Elias Lowenstein came to Memphis by way of New Orleans in 1854 and joined his three brothers in the dry-goods business founded by brother Benedict Lowenstein. The store flourished and became one of the city's leading department stores. Elias took control of the business after Benedict died and in 1890 built this large house on the edge of the fashionable Adams Avenue district.

The house has a blend of Italianate and Romanesque elements and features several beautiful stained-glass windows. In 1921, Celia Lowenstein, daughter of Elias, donated the property to the Nineteenth Century Club, an elite women's philanthropic club, to be used as a boarding home for young women, many of whom at the time were coming to Memphis from rural areas to work in factories during World War I. The home was staffed by a house

Lowenstein House. *Courtesy the author.*

mother who looked after the unmarried girls and enforced a strict set of rules governing social life. In 1979, the house became a treatment center for mental health outpatients.

10. SHELBY COUNTY JUVENILE COURT

616 Adams Avenue

The two cast-bronze dogs flanking the Adams Avenue entrance of juvenile court have stood guard over the property since the 1870s but not always peacefully.

The pair of statues was purchased in Europe in the 1870s by Captain William Decatur Bethell and placed in the garden of his home in Memphis. When Bethell subsequently moved to Denver, he gave, or loaned—the distinction would prove crucial—the dogs to his cousin, Mrs. H.M. Neely, who lived in a grand Victorian mansion that was then at this address. Mrs. Neely placed the dogs on either side of the walkway leading to the front steps of the house.

The City of Memphis acquired the house—dogs and all—in 1921 for the city's juvenile court. In the 1940s, the dogs became the target of a World War II scrap metal drive, bringing forth several competing litigants claiming an interest in the statues. The dogs were spared from destruction by a juvenile court judge, who summarily ruled that no one was going to take away "her" dogs.

In 1965, members of the Association for the Preservation of Tennessee Antiquities, which had acquired the nearby Woodruff-Fontaine House, wanted to move the dogs down the street, touching off another legal battle of tug-of-war. The city had since torn down the old Neely mansion, but the dogs remained outside the entrance to the new juvenile court building. Again, several litigants came forward claiming ownership of the dogs, including the granddaughter of Captain Bethell, who wanted the statues to go to the Woodruff-Fontaine House; she argued that since the dogs had been merely loaned to Mrs. Neely, they remained the property of the Bethell family. City attorneys argued that the dogs had been a gift, and that they belonged to the city when it acquired the Neely mansion "and all appurtenances" in 1921. Once again, however, the juvenile court stepped in, ruling that since nobody could conclusively prove ownership, the dogs would remain at the courthouse. They have stayed there to this day; only the dogs themselves know whether they stand silent guard outside their rightful home or faithfully await the return of their long departed master.

Chapter 9

Madison and Union Avenues

In the late nineteenth and early twentieth centuries, Madison Avenue—known as Banker's Row—was the heart of the city's financial district and was lined with banks and investment houses in opulent buildings, though small in scale by modern standards for bank headquarters. Most bank buildings were three to four stories tall, sometimes five, and presented an array of classical façades marching east from Front toward Third Streets. The Tennessee Trust Company was the first to break this mold in 1907 with a fifteen-story structure, ushering in an era of expansion that created the modern city skyline. The street's financial legacy continues today in the modern First Tennessee Building.

This tour proceeds eastward along Madison Avenue from Front Street to Fourth Street through the old financial district, then ventures to Union Avenue to some of the city's most iconic institutions: the Rendezvous Restaurant, the venerable Peabody Hotel and Sun Studio—the Birthplace of Rock 'n' Roll. All the sites visited in this chapter are within easy distance of each other, with the exception of Sun Studio, which is best visited by car at the end of the tour.

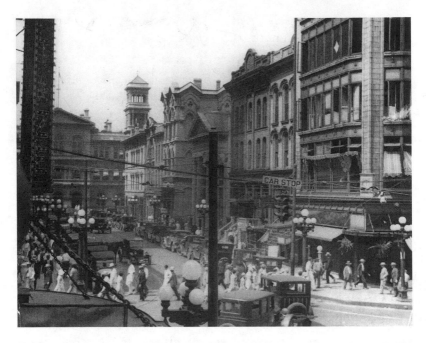

Madison Avenue, 1920s. *Courtesy of Memphis and Shelby County Room, Memphis Public Library and Information Center.*

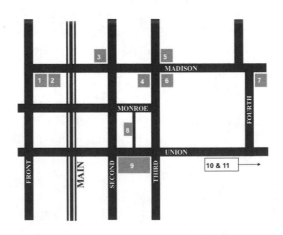

1. UNION PLANTERS BANK BUILDING

67 Madison Avenue

Built in 1924, this opulent twelve-story building was for many years the headquarters of Union Planters Bank, one of the major financial institutions in the city.

Union Planters Bank was founded after the Civil War and, by 1919, was the largest bank in Memphis and one of the ten largest banks in the South. It was the first bank in Memphis to take a departmental approach to banking and was the first to open a branch office (at a time when most banks in the country operated in only one location).

The building may be most recognizable today, at least by Tom Cruise fans, as the home of the law firm Bandini, Lambert & Locke in the 1993 movie *The Firm*. It was recently renovated into apartments; the marble-paneled lobby and mezzanine were converted to retail space, and a fifty-square-foot section was removed from the middle of the upper eight floors like a doughnut hole to provide natural lighting for interior apartments.

Originally, the building was only five bays wide along Madison Avenue; the four bays to the east were added in 1937. The expansion displaced an older building that once housed the *Appeal*, one of the city's oldest newspapers. The *Appeal* developed from the rather awkwardly named *Western World and Memphis Banner of the Constitution*, a weekly paper established in 1839. The name was changed to the *Appeal* after the presidential election of 1840, in which President Martin Van Buren was defeated by William Henry Harrison of the Whig Party; the name stood for an appeal to voters to reconsider the defeat of Van Buren, a Democrat.

The staunchly Democrat-leaning *Appeal* struggled in Memphis (where the rival Whig Party was more popular at the time) and changed owners in 1847, but it faced a more serious challenge with the outbreak of the Civil War. On June 2, 1862, as Union gunboats approached the city, the type and presses were loaded onto rail cars and shipped first to Grenada, Mississippi, then Montgomery, Alabama, and finally to Atlanta. Under the name of the *Memphis*

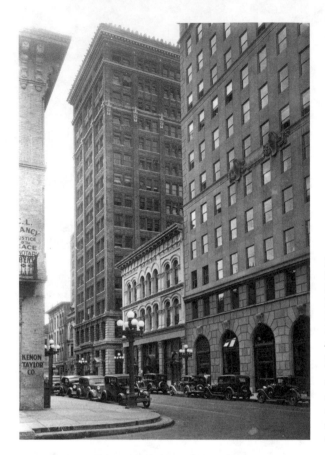

Madison Avenue from Front Street in the 1920s. From right: Union Planters Bank Building, former *Appeal* building and Tennessee Trust Building. *Courtesy of Memphis and Shelby County Room, Memphis Public Library and Information Center.*

Daily Appeal, the paper continued to publish articles supporting secession and the Confederate cause from city to city as it was chased around the South by Yankee troops. After the fall of Atlanta, the paper moved to Columbus, Georgia, where it was finally seized by the Union army, which destroyed the type. The presses, though, were hidden until the war was over and triumphantly returned to Memphis on November 5, 1865.

In 1894, the *Appeal* merged with the *Memphis Daily Commercial* (formed in 1889), to become the *Commercial Appeal*, the city's sole surviving newspaper today.

2. MADISON HOTEL

79 Madison Avenue

This fifteen-story building, constructed between 1904 and 1907 for the Tennessee Trust Bank, was the first building on Banker's Row to exceed the traditional four-story height for banks in the city. Since 2002, it has housed the luxurious Madison Hotel and boasts some of the finest views of downtown and the Mississippi River from its rooftop garden.

3. EXCHANGE BUILDING

9 North Second Street

Built in 1910, the nineteen-story Exchange Building was the tallest building in Memphis for almost twenty years. It was designed by Neander Woods, co-designer of the Goodwyn Building directly across Madison Avenue; the two buildings share many aesthetic features. The copper-sheathed French chateau roof of the Exchange Building is one of the most distinctive in the city.

The building was a joint venture of the Memphis Merchants Exchange and the Memphis Cotton Exchange, replacing the former four-story Romanesque structure that had opened on the same site in 1885. The cotton exchange operated here until moving to the corner of Front and Union in 1923.

Besides the cotton exchange, one of the building's more notable tenants was the insurance firm of Treadwell & Harry, founded in 1910 by two sisters, Mary Treadwell and Georgia Harry. Mary and Georgia, socialite daughters of wealthy steamboat magnate Milton Harry, took an active role in the ownership and management of the company at a time when it was virtually unheard of for women to be involved in serious financial matters of any kind. The sisters used their charm and social connections to garner the insurance business of many of the city's leading businessmen. The firm first specialized in automobile insurance, an entirely new aspect of insurance in

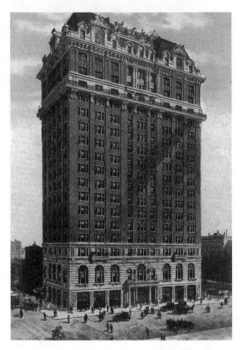

Left: Exchange Building, 1911 postcard view. *Courtesy of Memphis and Shelby County Room, Memphis Public Library and Information Center.*

Below: Old Cotton Exchange Building, 1883. *Courtesy of Memphis and Shelby County Room, Memphis Public Library and Information Center.*

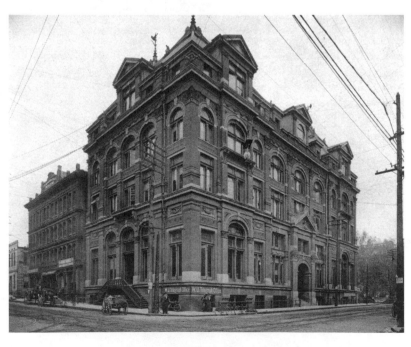

1910—so new, in fact, that when the chauffeur of one of their first clients was asked to "get the number off the motor" to fill out the paperwork, he thought he had to literally hack the number off the motor with a hammer and chisel. (The piece of metal was proudly displayed in the company's offices for many years.)

4. First Tennessee Bank Building

165 Madison Avenue

The First Tennessee Bank Building was the first in downtown Memphis to truly embrace modern architecture. Completed in 1964, the structure is an adaptation by local architect Walk C. Jones Jr., of Mies van der Rohe's famed Seagram's Building in New York City, and is a beautiful example of the international style.

The lobby is also noteworthy for the bank's First Tennessee Heritage Collection, a permanent art exhibition of paintings, drawings, lithographs and sculpture relating to Tennessee history. Behind the long row of tellers' cages is a remarkable and beautiful mural by Memphis artist Ted Faiers, completed by Betty Gilow after Faiers's untimely death, of scenes of the history and geography of the state. The bank lobby is open to the public; both the art collection and Faiers's mural are worth a look.

5. Sterick Building

Madison Avenue and Third Street—Northeast Corner

The Sterick Building, once known as the Queen of Memphis, was the tallest building in the city until the completion of the tower at 100 North Main in 1962. It was designed by Texan Walter Hedrick and financed by his father-in-law, R.E. Sterling, as a real estate venture; the building's name is a combination of their last names.

When it opened in 1930, the twenty-nine story Gothic-style tower accommodated more than two thousand workers and had

Sterick Building. *Courtesy of Memphis and Shelby County Room, Memphis Public Library and Information Center.*

its own barber shop, beauty parlor, bank and pharmacy along with stockbrokers' offices, eight high-speed elevators and a restaurant—the Regency Room—on the top floor with unparalleled views of the city. The exterior—originally white stone—sparkled in sunlight under a green tile roof, while the marble lobby, with a massive chandelier, was said to "rival the beauty of a Moorish castle."

Once fully occupied by a variety of large corporate tenants such as Chrysler Motors and Union Pacific Railroad, the building began a long decline in the 1960s along with the rest of downtown. In 1947, most of the original Gothic ornamentation on the structure, damaged from lightning strikes, was removed; in 1982, the gleaming white structure was painted gold and brown. It has been vacant since 1987 and is now a favorite location for urban explorers.

6. SCIMITAR BUILDING

Madison Avenue and Third Street, southeast corner

The Scimitar Building was built in 1902 by Napoleon Hill, the Merchant Prince of Memphis. Hill was the richest man in the city and lived in an ostentatious Victorian mansion across the street (at the site of the present-day Sterick Building). The initials N and H

can be found carved in stone beneath the bay windows above the Madison Avenue entrance. The building also features a charming row of lions and fleur-de-lis running beneath the cornice.

The building housed the offices of the *Memphis Press-Scimitar*, rival newspaper of the *Commercial Appeal*. Formed in 1926 with the joining of the *Scimitar* (established in 1880) and the *Press* (established in 1906), the *Press-Scimitar* saw its greatest days between 1931 and 1962 under the editorship of Edward J. Meeman, when it led a decades-long battle against the political machine of E.H. Crump.

Scimitar Building, 1907. *Courtesy of Memphis and Shelby County Room, Memphis Public Library and Information Center.*

7. YMCA Building

245 Madison Avenue

Built in 1909, the YMCA Building boasts an impressive row of gargoyles overlooking Madison Avenue.

President William Howard Taft was a special guest when the YMCA Building was dedicated October 27, 1909, with governors of twenty-seven states in attendance, including Tennessee's Malcolm Patterson. The president's party arrived by riverboat and was paraded through downtown to the new facility; the city paved Madison Avenue for the first time especially for the occasion.

YMCA Building.
*Courtesy of Memphis
and Shelby County Room,
Memphis Public Library
and Information Center.*

In October 2008, then senator Barack Obama paid a much quieter, low-key visit here, when he stopped in for a midnight game of basketball after the presidential debate in nearby Oxford, Mississippi.

8. RENDEZVOUS RESTAURANT

Charlie Vergos Way (between Union and Monroe Avenues)

The Rendezvous restaurant was opened in 1948 by Charlie Vergos, son of a Greek hotdog vendor. Vergos, who was running a diner at the time at this location, discovered a coal chute while cleaning out the basement. He vented a grill through the old coal chute and

switched his menu from ham and cheese sandwiches to ribs. Today, Rendezvous is one of the most famous barbeque joints in Memphis, a city that takes its barbeque seriously.

The restaurant has been featured in *Bon Appetit* magazine, named as one of the Top Five BBQ Joints in America by *Esquire* magazine and voted Best BBQ Restaurant by readers of *Southern Living* magazine. Famed for its spicy dry rub, Rendezvous is a favorite stop for visiting celebrities and VIPS, from the Rolling Stones to President George W. Bush and Japanese prime minister Junichiro Koizumi; President Bill Clinton and Vice President Al Gore once bet a rack of ribs on the outcome of an Arkansas–Tennessee college football game. The 1890s-era building is decorated inside with Memphis memorabilia and collectibles.

9. PEABODY HOTEL

149 Union Avenue

After a fire in 1923 in its original location at Main and Monroe, the Peabody Hotel moved to this location in 1925—a thirteen-story Italian Renaissance-revival building designed by architect Walter Ahlschlager. The centerpiece of the hotel, then as now, was the magnificent lobby with its travertine marble fountain. As essayist David Cohn famously wrote in 1935:

> *The Mississippi Delta begins in the lobby of the Peabody Hotel in Memphis and ends on Catfish Row in Vicksburg. The Peabody is the Paris Ritz, the Cairo Shepherd's, the London Savoy of this section. If you stand near its fountain in the middle of the lobby, where ducks waddle and turtles drowse, ultimately you will see everybody who is anybody in the Delta, and many who are on the make.*

The unique tradition of the Peabody Ducks began in 1932 when General Manager Frank Schutt and his friends, relaxing in the lobby bar with some good Tennessee whiskey after a weekend hunting trip,

Peabody ducks, 1962. *Courtesy of Memphis and Shelby County Room, Memphis Public Library and Information Center.*

thought it would be humorous to put their live decoy ducks in the fountain. (The use of live ducks as decoys was a common hunting practice until it was outlawed by the federal government in 1935.) The ducks delighted the hotel guests, and since then ducks have been in the fountain every day. In 1940, bellman Edward Pembroke, formerly a circus animal trainer, volunteered to care for the ducks and taught them to march into the lobby, initiating the famous Peabody Duck March. Pembroke was given the title of Duckmaster and served in that position until 1991. The Peabody Duck March has become a tradition that has made the hotel famous.

The Peabody also played an important role in Memphis' musical history. During the 1920s and '30s, talent scouts for major record labels recorded local blues musicians in the hotel's guest rooms; such early field recordings, a common practice of the day, are some of the only remaining historical records of popular local performers and

songs that otherwise would have been lost to memory. Later, during the 1930s and '40s, the hotel's Skyway Ballroom and its adjacent outdoor Plantation Roof was one of just three national live radio broadcast sites during the Big Band Era. Recording engineer Sam Phillips, who managed the live broadcasts for WREC, later founded the famous Memphis Recording Service, today's Sun Studio.

In 1981, the hotel reopened after a six-year, $25 million renovation that restored it to its former glory as the Grand Dame of the South.

10. SUN STUDIO

706 Union Avenue

Sun Studio is the name given to this remarkable recording studio that literally changed the world. Aptly described as the Birthplace of Rock 'n' Roll—the first rock 'n' roll single was recorded here in 1951—the studio also launched the careers of Elvis Presley, Johnny Cash, Jerry Lee Lewis, Carl Perkins, Roy Orbison and a host of others.

Originally known as the Memphis Recording Service, the studio was opened by Sam Phillips in January 1950. Phillips was born in Florence, Alabama—the same hometown as Father of the Blues W.C. Handy—and came to Memphis at age twenty-two to work for radio station WREC. Phillips had bigger plans, however. He had been captivated by the music of the black community since the days of his rural Alabama youth, and in January 1950, he followed his dream of opening his own recording studio. Although the studio's motto was "We Record Anything—Anytime—Anywhere," Phillips's aim was to record the great blues musicians he heard on Beale Street, black artists who otherwise might not have been heard; he was convinced that this music could gain mainstream acceptance if given the chance.

Phillips signed a lease on this small storefront and opened his doors to the soulful guitars and voices of such local talent as B.B. King and Howlin' Wolf. Initially, he leased the recordings to out-of-town independent labels; among these early recordings was *Rocket*

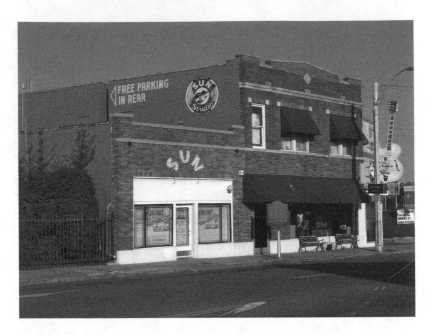

Sun Studio. *Courtesy the author.*

88, a single by Jackie Brenston and his Delta Cats (with Ike Turner on the piano) that, for its unintended use of guitar distortion—the band's amplification equipment was damaged and was "fixed" with newspaper wadded up and stuffed around the speaker cone—is credited as the first rock 'n' roll song.

After losing some of his most promising talent to other record labels, Phillips decided to launch his own label and founded the Sun Record Company in March 1952. For the first two years, Sun Records released a string of blues recordings, along with some hillbilly and gospel numbers. During this time, Phillips became convinced that his records would sell if he could make black music more accessible to a white audience. Then, in 1954, a nineteen-year-old kid named Elvis Presley started hanging around the studio. At first, Phillips was unimpressed by Elvis's attempts at crooning popular hits, but when he broke out one night into *That's All Right*, a song first recorded by bluesman Arthur "Big Boy" Crudup, Phillips found what he had been looking for. Elvis brought a hillbilly sound

to the music while retaining the spirit and energy of black rhythm and blues, and rockabilly was born.

Elvis recorded ten singles at Memphis Recording Service for Sun Records and became an international star. The studio's direction changed dramatically. The phenomenal success of Elvis brought other white musicians to Phillips's door, artists such as Johnny Cash, Jerry Lee Lewis and Carl Perkins, all of whom launched their careers at Sun Records. On the strength of hits such as Cash's *Folsom Prison Blues*, Perkins's *Blue Suede Shoes*—the first million-seller for Sun Records and a hit on national country, pop and R&B charts—and Lewis's instant classics *Whole Lotta Shakin' Going On* and *Great Balls of Fire*, Phillips outgrew the tiny studio and moved to larger digs around the corner at 639 Madison Avenue in 1959.

The studio lay vacant until 1987, when it was reopened as Sun Studio, a working studio and tourist attraction. It was designated as a National Historic Landmark in 2003, the only music studio to be so honored. The twenty-by-thirty-five-foot studio is considered hallowed ground by many of the world's leading entertainers, many of whom come here, like the thousands of ordinary tourists each year, to stand in the spot where Elvis stood when he sang *That's All Right*. Modern bands and performers such as U2, Ringo Starr and Tom Petty have all recorded here, hoping to catch a bit of the magic within its walls. The excellent one-hour studio tour is highly recommended for anyone with an interest in Memphis music.

The building on the corner adjacent to the white-storefront studio was once Taylor's Restaurant; it is now the Sun Studio gift shop. Sam Phillips had a regular booth in the café and would often do paperwork or meet with musicians here over a cup of coffee and a bite to eat. The checkered floor and tin ceiling are original to the restaurant. Upstairs was a boarding house; Jerry Lee Lewis, Carl Perkins, Roy Orbison and many others rented rooms here while working at the studio next door.

11. FORREST PARK

Union Avenue and South Manassas Street

This eight-acre park was established in 1904 to honor Confederate general Nathan Bedford Forrest. Both celebrated and reviled, Forrest is one of the more controversial figures of the Civil War era. Born to a poor family in Chapel Hill, Tennessee, and largely uneducated, he moved to Memphis and amassed a fortune prior to the Civil War in cotton plantations, real estate and the slave trade. He was one of the city's most prominent slave traders and operated a large slave yard on Adams Avenue between Second and Third Streets. In 1858, he was elected as a city alderman, serving three terms.

Forrest enlisted in the Confederate army as a private, but due to his wealth and status he was given the rank of lieutenant colonel and invited to lead a cavalry regiment, a role he seemed born to fill. Establishing a reputation for boldness and personal bravery in the early battles of Forts Donelson and Shiloh, for much of the war he led raids and brilliant tactical campaigns in middle and west Tennessee, causing such disruption to Union army supply routes that General Sherman considered him the most dangerous man in the Confederacy; Sherman reportedly said that he should "be hunted down and killed if it costs 10,000 lives and bankrupts the treasury."

After the war Forrest returned to Memphis and engaged in several business ventures. He also became the first grand wizard of the Ku Klux Klan, although he subsequently resigned and ordered the disbanding of the organization; late in life he famously gave a speech at the Memphis fairgrounds to a black audience and called for understanding and cooperation between the races.

He died in 1877 and was buried in Elmwood Cemetery. In 1906, the remains of Forrest and his wife were reinterred here under the great equestrian statue.

Pinch District–North Memphis

T he Pinch is traditionally defined as the area just north of the current downtown, bounded by Front Street to the west and Third Street to the east, A.W. Willis Avenue on the north and the current Interstate 40 on the south. It was the city's first commercial district and the site of its earliest buildings, now almost all lost. Named for the "pinch-gut" appearance of its early Irish immigrant residents who came to America to escape the potato famine of the 1840s, the Pinch was once a busy, heavily populated neighborhood. It was home to various immigrant groups over the years—Italians, Greeks and others—and was the center of the city's Jewish community in the early 1900s.

In the late twentieth century, suburban flight and misguided urban renewal projects dramatically changed the nature of the Pinch, though it is slowly on its way back, fueled in no small part by the Uptown community and the presence of the world-renowned St. Jude's Children's Research Hospital.

1. AUCTION SQUARE

A. W. Willis Avenue and North Main Street

One of four squares laid out in the original city plan, Auction Square has been heavily altered over the years. It was a focal point of commerce in the city's early years and was the site of the city's first food market.

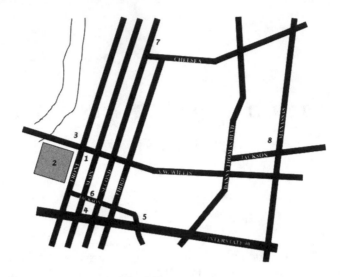

Contrary to some local lore, slaves were never auctioned here; the large block in the middle of the park dates from 1924 and was presented as a gift from the Colonial Dames of America to mark—erroneously—the site where Hernando de Soto first viewed the Mississippi River. Although Memphis was a major slave trading center, slaves were not sold at public auction but instead sold by individual dealers at their own establishments, many of which were located on Adams Avenue near the current site of the courthouse.

The area here was the site of a Spanish fort, called San Fernando de las Barrancas (St. Ferdinand on the Bluffs). Built in 1795, it was dismantled and abandoned just two years later after Spain ceded to the United States all claims to lands east of the Mississippi River and north of the 31st parallel. In 1797 it was also briefly the site of an early American fort, Fort Adams, before the construction of Fort Pickering on a superior location higher on the bluff to the south.

2. Pyramid

A.W. Willis Avenue and North Front Street

In 1897, Memphis architect James Cook was chosen to design a structure for the Memphis pavilion at the Tennessee Centennial and International Exposition in Nashville. Hoping to rival Nashville's replica of the ancient Greek Parthenon, Cook designed an Egyptian pyramid, evoking the city's namesake. It was an architectural sensation, one of the most highly acclaimed of the exposition.

The original plans for constructing the pyramid pavilion so that it could be dismantled, brought back to Memphis and reassembled at Front and Monroe Streets were ultimately rejected as too expensive, but the dream never died. In the 1970s and '80s, the idea surfaced again, this time as a golden glass structure on top of the bluff in the southern part of the city with shops, museums and other attractions—a signature landmark to rival the St. Louis Arch. Moved for practical and political reasons to its current site just north

Pyramid. *Courtesy the author.*

of the convention center, construction began in 1989; the Pyramid Arena opened its doors two years later.

It is the sixth largest pyramid in the world, behind four ancient pyramids in Egypt (including the Great Pyramid of Giza) and the Luxor Hotel in Las Vegas. It stands over thirty-two stories tall—about fifteen feet taller than the Statue of Liberty—and has a seating capacity of over twenty thousand. The arena was originally the home of the Memphis Grizzlies and the University of Memphis basketball teams before those teams moved to the FedEx Forum. It has also hosted numerous concerts and other events.

At the time of this writing, the Pyramid is closed and vacant, and its fate remains unknown, although the city is in negotiations with outdoor retailer Bass Pro Shops to convert the Pyramid into an attraction with shops, restaurants, offices and a Mississippi River exhibit.

3. OLD SHELBY COUNTY JAIL

A.W. Willis Avenue and North Front Street

The iron fence surrounding this property is all that remains of the Old Shelby County Jail, built in 1868. Architect James Cook's jail was supposedly escape proof, a double-walled structure with the space between the walls filled with sand. If an inmate dug a hole through the wall, sand would flood his cell; in the meantime, as the level of sand between the walls fell, monitors in the sand would fall also, pulling a wire that set off an alarm. Cook, a Memphis transplant from England, had his ingenious system patented by Queen Victoria, but it proved to be no match for Memphis criminals. In 1924, Diggs Nolen, a notorious criminal serving a twenty-year sentence for fraud and narcotics dealing, chipped a hole two feet wide through the rear wall of the jail, crawled into the interior jail yard and scaled the exterior wall to freedom. Forty other prisoners escaped before the breach was discovered in what remains the largest jailbreak in Memphis history.

Nolen, incidentally, was caught the next day. He had commandeered a taxi and spent most of the night visiting bars and

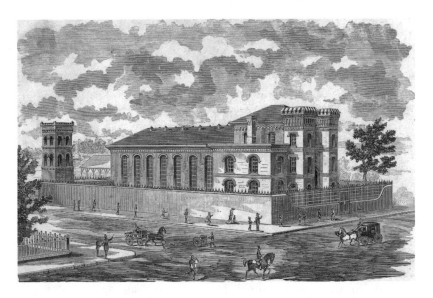

Old Shelby County Jail, 1876. *Courtesy of Memphis and Shelby County Room, Memphis Public Library and Information Center.*

liquor stores; he was found passed out in the back of the taxi on the corner of Mulberry Street and Linden Avenue, "scantily clad and drunk as seven million dollars," according to the arresting officers. He later said he simply wanted to see his wife and drink some whiskey.

In 1936, the Victorian-era jail was demolished and replaced with an art-deco structure, now vacant, but formerly the city dog pound.

4. J.T. WALSH BUILDING

326–328 North Main Street

The two faces carved in stone above the doorways of this building are said to be fanciful likenesses of brothers John T. and Anthony Walsh, who ran a successful grocery and dry-goods store here in the late 1800s. John Walsh was an important figure in the Irish politics of the Pinch and had strong influence in city elections; he held court

in a saloon in the rear of the building on the Commerce Street side, which became the unofficial headquarters for First Ward politicians. John Walsh served as fire commissioner, police commissioner and eventually vice mayor before founding the North Memphis Savings Bank, a branch of Union Planters Bank located in the Crump Building at Adams Avenue and Main Street.

5. ST. JUDE'S–ALSAC PAVILION

262 Danny Thomas Place

The world-renowned St. Jude Children's Research Hospital is one of the, if not the most, significant developments in Memphis in the latter half of the twentieth century. The hospital, founded in 1962, is a leading pediatric treatment and research facility focused on children's catastrophic diseases and has significantly increased the survival rate of many forms of childhood cancer. In 1996, Dr. Peter C. Doherty

St. Jude Children's Research Hospital and Danny Thomas, 1960s postcard. *Courtesy of Memphis and Shelby County Room, Memphis Public Library and Information Center.*

received a Nobel Prize for medicine for his work here, and St. Jude's remains at the forefront of advances in cancer treatment.

The hospital was founded by actor and comedian Danny Thomas. In 1941, Thomas, then a struggling young entertainer, knelt in a church before a statue of St. Jude—patron saint of hopeless causes—and asked the saint to "show me my way in life, and I will build you a shrine." Not long afterward, he received an unexpected break in show business, and soon his career flourished, first in radio, then in films and then with a highly successful television show—*Make Room For Daddy*, later known as *The Danny Thomas Show*. By the early 1950s, he was an internationally beloved (and well-paid) entertainer. Not forgetting his vow, Thomas and a group of Memphis businessmen developed the idea of building here a unique hospital and research center.

The son of Lebanese immigrants, Thomas (whose real name was Amos Alphonsus Muzyad Yakhoob) turned to other Americans of Arab-speaking heritage to help with fundraising and founded the American Lebanese Syrian Associated Charities (ALSAC) in 1957. ALSAC today is the exclusive fundraising organization for St. Jude's. In front of the hospital, the gold-domed ALSAC Pavilion resembles a Mediterranean-style mosque and features exhibits and memorabilia of Danny Thomas's career in entertainment and the history of St. Jude's. Thomas, who died in 1991, and his wife, Rose Marie, were buried in a crypt in the Pavilion's garden.

6. ANSHEI MISCHNE SYNAGOGUE

112 Jackson Avenue

The Jewish community of Memphis dates back to the 1840s when immigrant German Jews first came to the city, often as peddlers from New Orleans, St. Louis or Cincinnati. Immigrants such as Isaac and Jacob Goldsmith, the Lowenstein brothers and Abraham Schwab opened small shops in the city and eventually became leading merchants. In 1853, the first synagogue was established in the city in a former bank building in Market Square.

Though many Jews fled the city during the yellow fever epidemics of the 1870s, the community soon rebounded with the arrival of a wave of immigrants from Eastern Europe in the 1880s and '90s. These Jewish immigrants settled mostly into the Pinch, which came to resemble a smaller version of New York City's Lower East Side.

In the first decades of the twentieth century, many small synagogues dotted the Pinch; most of the new immigrants were traditional in their worship and founded separate congregations often based around their area of origin. Many of these congregations did not last, often closing once their membership moved to other parts of the city.

This building, one of the last remaining of such former synagogues in the Pinch, was originally the Anshei Mischne (People of the Book) Synagogue. The congregation was established by ten men who broke away from a larger orthodox congregation in 1900. Meeting first in a rented house, then in a brick building on this site, the congregation built the current structure in 1927. Although Anshei Mischne had 175 members in 1941, the congregation eventually disbanded after most of the members moved out of the Pinch to the eastern part of Memphis. For a short time, the building was converted to a nightclub, but it now stands vacant.

The Jewish community in Memphis—now residing mostly in the eastern suburbs—remains the largest in Tennessee and includes the largest Orthodox congregation in the United States.

7. BURKLE ESTATE–SLAVEHAVEN

826 North Second Street

Jacob Burkle, a German immigrant, came to Memphis in the mid-nineteenth century and opened a stockyard and bakery. He built this simple white frame house in 1849, known today as the Burkle Estate, in a then sparsely populated area north of the Gayoso Bayou. A trap door and hidden chambers under the house support local lore suggesting that the house was once a way station on the

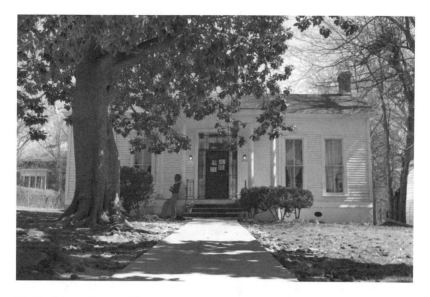

Burkle Estate. *Courtesy the author.*

Underground Railroad for runaway slaves prior to the Civil War. It is said that the cellar connected to a tunnel leading to the Mississippi River, where slaves could stow away on boats headed north to freedom. Now a museum, the house features exhibits and artifacts from slavery days and the slave trade in Memphis.

8. Humes High School

659 Manassas Street

Elvis Presley attended Humes High School from 1948 (age thirteen) to his graduation in 1953. With over one thousand students, it was much larger than any school he had attended in Tupelo. Within an hour of going inside on his first day, Elvis scurried back home. He told his mother that he was afraid of the size of the school and feared getting lost inside, never to be found again. Gladys let her son stay home that day but walked him to school every morning after that to make sure he went.

Humes High School. *Courtesy the author.*

At first, Elvis was not terribly popular in high school. Although many of the students were poor, Elvis was poorer than most, and he was teased about his patched-up jeans and country style. He also had a severe case of acne and warts on his hands. (The acne and the warts were treated when Elvis went to Hollywood in 1956.) He did, however, meet Robert "Red" West, Marty Lacker and George Klein, friends who would remain loyal to him for the rest of his life and who formed the core of the so-called Memphis Mafia, or as Elvis always referred to them, the Guys.

During his junior year, Elvis grew sideburns and a ducktail and started favoring flashy clothing similar to what the black musicians wore on Beale Street, a risky move in the conservative, conformist South of the 1950s; a number of his classmates considered him peculiar, even weird. On April 9, 1953, however, he became one of the most popular kids in school when he wowed the audience at the school's annual variety show. There were no swivel hips, but Elvis played guitar and sang his heart out. The ovation was thunderous and long; Elvis was sixteenth of twenty-two kids to perform but, in the words of one classmate, "the show really finished when Elvis did." Another classmate added, "To me, that was when rock and roll was born."

Chapter 11

South Main Arts District

In the nineteenth century, South Main Street was primarily a muddy residential street lined with Victorian homes, linked to downtown by the trolley. The completion of Union Station in 1912 and Central Station in 1914 dramatically changed the face of the neighborhood, making it the bustling Gateway to Memphis. Most of the existing structures on South Main Street—originally warehouses, hotels, bars and brothels—date from this era, built during the early decades of the twentieth century to serve the needs of travelers and railroad commerce. The rise of the automobile in the 1950s meant a decline in the city's railroad traffic and this, combined with the general decline in the downtown area in the wake of Martin Luther King's assassination, caused the neighborhood to fall into neglect. The 1980s saw renewed interest in the area and, in 1982, the eleven blocks of South Main Street from the Chisca Hotel to Central Station was listed on the National Register of Historic Places.

This tour proceeds south from the former Chisca Hotel to Central Station on G.E. Patterson Avenue. The interesting but abandoned old Tennessee Brewery, on Tennessee Street three blocks west of the train station, is also worth a look.

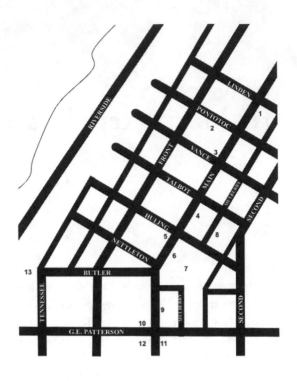

1. Hotel Chisca

262 South Main Street

When the Hotel Chisca opened in 1913, it was the largest and grandest hotel in the South Main district. The Chisca contained Turkish baths, a barber shop, a liquor store, a beauty parlor, the Yellow Cab Company, a cigar store and a green room lounge for performers from the nearby Orpheum Theater.

The Chisca is most famous as the home of radio station WHBQ and the groundbreaking *Red, Hot & Blue* program hosted by Dewey Phillips. Broadcasting from the hotel's "magazine floor"—the mezzanine—Dewey Phillips was one of the pioneering deejays who, along with Cleveland's Alan Freed, is credited with promoting the new sound of rock 'n' roll. Dewey started his radio career in 1949 and was the city's leading radio personality for close to ten years.

South Main Arts District

Hotel Chisca, 1919 postcard view. *Courtesy of Memphis and Shelby County Room, Memphis Public Library and Information Center.*

Phillips's on-air persona was a speed-crazed hillbilly with a frantic delivery and entertaining sense of humor. He also had a keen ear for music the listening public would enjoy, and he embraced both black and white music. Along with programming on rival station WDIA, Phillips's influential show *Red, Hot & Blue* did much to bridge the artificial racial barriers of the 1950s.

In July 1954, Phillips was the first deejay to broadcast Elvis Presley's debut record, *That's All Right*, playing it numerous times in a row and causing a sensation among the city's teens. Elvis's first radio interview was also conducted at the Chisca by Phillips.

The Chisca was also briefly the home of the automobile industry in Memphis. The Southern Automobile Manufacturing Company (advertised as "A Million Dollar Organization Composed of Southern People") was founded in 1920 and had its offices in the hotel; to generate publicity and attract investors, the company displayed outside the hotel entrance a gleaming red prototype known as the Southern Six, the design and styling of which was said to be far ahead of its time. The plan took an unexpected turn, however, when police officers chased a bootlegger and gambler down Main Street and pursued him into the Chisca garage, where the car was

stored at night; a gun battle ensued and the Southern Six, caught in the crossfire, was shot full of holes, ending the dream of bringing Memphis innovation to the nation's automobile industry.

In 1959, the Chisca expanded with the addition of a four-story motel in the rear of the hotel, with a sun deck and a year-round swimming pool in between. The hotel, however, fell victim to the general decline of South Main and downtown in later years and closed in 1971.

2. PONTOTOC HOTEL

69 Pontotoc Avenue

Built in 1906, the Pontotoc Hotel flourished for a time as a fine hotel; like its neighbor the Chisca, it, too, had Turkish baths. In the 1920s, the fates turned and it became one of the city's better-known brothels. Later, in 1929, it was purchased by George Touliatos, owner of a theater on Front Street, and provided lodging for actors and actresses from his theater and others, including the Orpheum. It is now a private residence.

3. GREEN BEETLE TAVERN

327 South Main Street

Constructed before 1910, this Beaux Arts-style building has ornate stone window arches and a decorative pressed metal cornice. The Green Beetle Tavern, in operation here since 1939, was the site of a popular speakeasy during Prohibition. It is said that a section of paneling in the bar covers bullet holes in the wall made by the Depression-era gangster Machine Gun Kelly, a Memphis native.

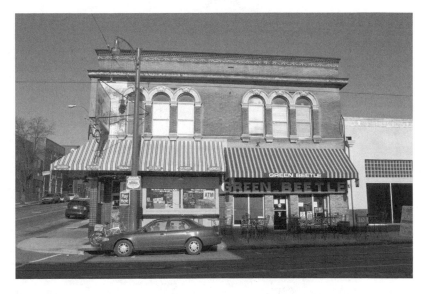

Green Beetle Tavern. *Courtesy the author.*

4. 378–384 SOUTH MAIN STREET

These matched buildings on the east side of Main between Talbot and Huling Streets, built in 1905, housed several businesses, including the elegant Paris Dress Shop in 1913. The triple-arched windows and circular attic vents still lend a distinctive charm to the streetscape.

In the 1920s and '30s, the buildings had a distinction of another kind. Upstairs at 382½ South Main was the private resort of red-haired Elizabeth Monaghan, known to police at the time as "Memphis' most arrested woman." She was first docketed on a charge of vagrancy (a charge commonly applied to prostitutes) in 1921 and, over the next eleven years, was arrested forty-eight times. She was married to Burney "Red" Monaghan, a notorious gambler and bootlegger with a rather impressive rap sheet of his own. Her establishment here on South Main Street was said to be "well-known to the police and certain of the public."

382½ South Main in the 1950s. *Courtesy of Memphis and Shelby County Room, Memphis Public Library and Information Center.*

5. JAY ETKIN GALLERY

409 South Main Street

Built in 1912, this former warehouse originally housed the White Wilson Drew Company, a wholesale grocery firm that marketed Puck Brand goods. The large ceramic bas relief on top of the building depicts the trickster Puck as he appeared in the White Wilson Drew logo. The building is nearly identical to 431 South Main (currently See the Difference Interiors); both buildings, along with other grocery warehouses in this same block of Front Street, were served by spur lines from the railroad tracks just to the south and west.

6. YOUNG & MORROW BUILDING AND JIM'S GRILL

422 and 418 South Main Street

The Young & Morrow Building, a beautiful Beaux Arts-style building, was built in 1910 for the Tri-Tone Drug Company and Jopling Perfumery, with residences above. The building next door, at 416–418 South Main, built in 1912, originally hosted a men's furnishing store and a soda fountain fixture company.

In 1968, these buildings housed the Canipes Amusements Company (at 422) and a restaurant known as Jim's Grill; between

Puck of White Wilson Drew Company at 409 South Main. *Courtesy the author.*

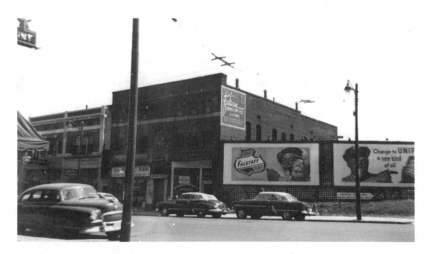

Young & Morrow Building, 1953. *Courtesy of Memphis and Shelby County Room, Memphis Public Library and Information Center.*

the two buildings was a narrow doorway (now marked 418), which was the doorway to a rooming house in the upper floors of the two buildings operated by one Bessie Brewer. It was in the evening of April 4, 1968, from a window in the second-floor bathroom in

the rear of Bessie Brewer's rooming house that James Earl Ray assassinated Dr. Martin Luther King Jr.

Conspiracy theories abound, but Ray, an Illinois native and hardened criminal, had been following King in Georgia before coming to Memphis. He confessed to the assassination and was convicted in 1969. Two residents of the second floor of the rooming house saw a man fitting Ray's description fleeing toward the front of the building and down the stairs immediately after the shot was fired, while two patrons inside the Canipes Amusements store heard a thud and saw a man matching Ray's description running past the entry to the store before driving away in a white Mustang. It appeared that the man dropped a package or bundle in the doorway to the Canipes store; it was found to contain a Remington rifle with Ray's fingerprints, a scope, a pair of binoculars purchased by Ray in Memphis just hours before the killing, a radio and some clothing. The rifle was traced to a gun store in Birmingham, Alabama, where it had been purchased by a man matching Ray's description; Ray's fingerprints were also found in the Mustang, located a week later in Atlanta.

Ray fled to Canada, where he obtained a false Canadian passport and flew to London; there, he was apprehended by British authorities while attempting to board a flight to Brussels and was extradited to Memphis. Under questioning in the Shelby County Jail, Ray confessed and pled guilty to avoid the death penalty.

7. Lorraine Motel

406 Mulberry Street

The Lorraine Hotel, built in 1920 as the Windsor Hotel, was one of many hotels in the South Main district catering to railroad passengers from nearby Union and Central Stations. In 1942, it was purchased and renamed by Walter Bailey, a former Pullman car porter, and his wife, Lorene, who soon made it the premier African American hotel in the city. It attracted families and travelers as well as an upscale clientele of black businessmen and entertainers. In 1964, the hotel on the corner of Mulberry and Huling Streets was expanded with the addition of a

South Main Arts District

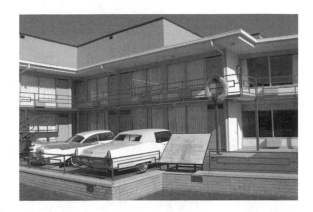

Lorraine Motel.
Courtesy of the author.

swimming pool and, stretching south along Mulberry Street, a separate building around a motor court called the Lorraine Motel. The motel was a popular gathering spot for the musical artists at the nearby Stax Records studio in South Memphis; songs such as *In the Midnight Hour* and *Knock on Wood* were written here as studio personnel took refuge from the summer heat in the air-conditioned motel rooms of visiting Stax artists such as Wilson Pickett, Eddie Floyd and Otis Redding.

Today, of course, the Lorraine Motel is most well-known as the site of the assassination of Dr. Martin Luther King Jr. on April 4, 1968.

King was invited by local civil rights leaders to lend support to the city's black sanitation workers who had gone on strike in February of that year against deplorable working conditions and poverty-level wages; they also sought official recognition of their union. He ultimately made three visits to Memphis during the strike.

On March 18, 1968, King spoke at a rally held at the Church of God In Christ's Mason Temple in South Memphis. Energized by the enthusiasm of the strikers and their supporters, King promised to return later in the month and lead a large march on city hall. That evening, after the rally, King met with other leaders here at the Lorraine and planned strategy. A traveling gospel choir of black teenagers staying at the motel serenaded King and his colleagues from the parking lot while they worked.

King returned to Memphis on the morning of March 28, the day of the planned march. He was taken directly from the airport to Clayborn Temple on Hernando Street and led fifteen thousand people up Beale

and Main Streets toward city hall. What was supposed to be a peaceful, nonviolent march for justice, however, turned ugly as certain rowdy elements in the rear of the column began breaking store windows on Beale. Looting ensued, and the police moved in. The demonstrators dispersed in chaos, and King was taken by his aides to the first place of safety they could find: the Holiday Inn Rivermont. In rioting that continued throughout the evening, hundreds were arrested, more than sixty people were injured and one young black man was killed.

The outbreak of violence deeply affected King, who had devoted his life to nonviolent civil disobedience. He vowed to return to Memphis yet again and lead another march from Clayborn Temple. The march was originally scheduled for April 3 but was delayed by the federal courts and rescheduled for April 5.

King arrived in Memphis on the morning of April 3. The city was under martial law, and National Guard troops patrolled the streets; the possibility of further violence weighed heavily on everyone's mind. Given the situation, King's aides initially booked rooms at the Peabody Hotel on Union Avenue, believing that the Lorraine Motel, with its exposed balconies, was simply not safe. King, however, had been branded a hypocrite by the Memphis newspapers for retreating to the white-owned Holiday Inn Rivermont to escape the riots that disrupted the March 28 demonstration; to counter such charges the decision was made to stay at the Lorraine.

Motel owner Walter Bailey and his wife, Lorene, gave King his usual room, Room 306, the largest in the motel. King's right-hand man, Ralph Abernathy, remarked that they had stayed in that room so often during their visits to Memphis throughout the 1950s and '60s that it was jokingly referred to as the King–Abernathy Suite. On the evening of April 4, King planned to attend a dinner at the home of a local minister. In an upbeat mood, dressed for dinner and waiting for Abernathy to join him, he wandered out onto the balcony, joked with some of his staff and spoke briefly to associates in the parking lot below. At 6:01 p.m., the fatal shot rang out, and King fell dead. The spot where he fell is today marked by the white wreath on the balcony.

Walter Bailey suffered not only the loss of his friend Dr. King but also a more personal loss that evening. His wife, Lorene, working the hotel's switchboard at the time, had a cerebral hemorrhage upon

hearing the news of King's assassination. She never recovered from the shock and died five days later on April 9.

The Lorraine Motel, and indeed the entire neighborhood, declined steeply in the aftermath of the assassination. Bailey was forced to declare bankruptcy in 1982, and the motel was ordered to be sold on the courthouse steps; on the morning of the auction, a group of Memphis businessmen purchased it with plans to remodel it as a lasting shrine to Dr. King and the movement he led and inspired. Their plans evolved into today's National Civil Rights Museum, which opened its doors in 1992.

8. SHOTGUN SHACKS AND THE RESIDENCES OF SOUTH MAIN

372–384 Mulberry Street

These three small houses and the adjacent apartment building are virtually all that remains of a once vibrant, dynamic residential community along Mulberry Street. Laid out in 1840, Mulberry Street was one of many nice residential streets in the then independent city of South Memphis. By the early twentieth century, it was an ethnically mixed, working- and merchant-class neighborhood; many of its residents worked on or around Beale Street to the north. By the 1940s, Mulberry Street had evolved into something of a mirror image of Main Street, with hotels, shops and restaurants but catering to blacks instead of whites.

The three small shotgun-style houses, built in 1890, were typical of the residences in the neighborhood. The building at number 384—now an upscale apartment building known as the Residences of South Main—was a former "negro tenement" in the 1920s.

9. 502–520 SOUTH MAIN STREET

The stretch of buildings on the east side of South Main Street in the middle of the block between Butler and G.E. Patterson has been featured in numerous movies such as *Walk the Line*, *Great Balls of Fire*,

502–520 South Main. *Courtesy the author.*

and many others. Built between 1912 and 1920, the buildings each retain the look of an earlier era and together constitute the heart of the South Main Historic District.

Of special note is the former Pullman Hotel at 520 South Main; built in 1912, it was named for the Pullman railroad sleeper cars that once rolled through nearby Central and Union train stations. It was one of many hotels and rooming houses that served passengers and railroad workers in the South Main area. Like many buildings in the area today, the upper rooms have been converted into private residences.

10. ERNESTINE & HAZEL'S

531 South Main Street

A church once occupied this site in the late 1800s; the present structure, built in the 1920s, housed a drugstore in the 1930s and '40s before it was purchased in the early 1950s by Ernestine Mitchell and her business partner Hazel Jones. Ernestine, wife of Sunbeam Mitchell, who ran a hotel and blues joint on Beale Street, converted

174

the drugstore into a bar and hotel with hopes of capturing some of the traffic from Central Station. With Ernestine's connections to her husband's famous Beale Street club, it soon became a favored spot for musicians, and it remains to this day a lively nightspot. At some point Ernestine and Hazel both came to realize that they could make as much or even more money by renting the upstairs rooms by the hour instead of by the night, and the second floor became one of the city's most famous brothels. The faded lettering of "Mitchell Hotel/Rooms by the Hour" can still be seen near the side door on the south side of the building along G.E. Patterson Street.

In the 1960s, the bar downstairs was a hangout for the likes of Otis Redding, Steve Cropper and other musicians at Stax Records. B.B. King, Tina Turner and other national stars were frequent visitors; Ray Charles once spent a week here, he had such a great time. The bar is famous for harboring numerous ghosts, especially in the stairwell and second-floor rooms; it also has a haunted jukebox known at times to play on its own—even when unplugged.

The bar's funky ambiance is a favorite of Hollywood film directors and has been featured in movies such as *The Rainmaker*, *21 Grams*, and *Black Snake Moan*.

II. ARCADE RESTAURANT

540 South Main Street

The Arcade Restaurant is the city's oldest restaurant, having been in operation continuously since 1919. From the time of its opening to 1968, the Arcade was open twenty-four hours a day, seven days a week. It is said that when it was decided to close in the evenings in the aftermath of the King assassination, no one could find the key—the door hadn't been locked in decades.

Greek immigrant Speros Zepatos founded the diner in a small, one-story, wood-framed building on this site, which was torn down and replaced with the current structure in 1925. Plans to add a hotel atop the building never materialized, but in the 1950s Speros's son, Harry Zepatos, transformed the bustling diner into the city's hippest

Arcade Restaurant.
Courtesy the author.

eatery. Elvis Presley was a regular here and had a favorite booth; the interior, with its distinctive boomerang tabletop designs, has changed little since then. It is a favorite of filmmakers and photographers; scenes from *Walk the Line, The Firm, The Client, 21 Grams,* and *Great Balls of Fire,* just to name a few, have all been filmed in the restaurant.

The Arcade is still owned and operated by the Zapatos family and is a great destination for breakfast or lunch.

12. CENTRAL STATION

545 South Main Street

Central Station was built in 1914, replacing the older Yazoo and Mississippi Valley Depot. By 1935, it was the hub of railroad transportation in the city and saw the arrival and departure of more than fifty trains a day, transporting everything from blues musicians to World War II servicemen to tourists and cargo. The station's sister depot, Union Station (now lost), was located just a few blocks east, making the South Main area the Gateway to Memphis.

Central Station is still in use today; the Amtrak train City of New Orleans, made famous by the haunting Arlo Guthrie song, stops here twice a day in its run between Chicago and New Orleans.

176

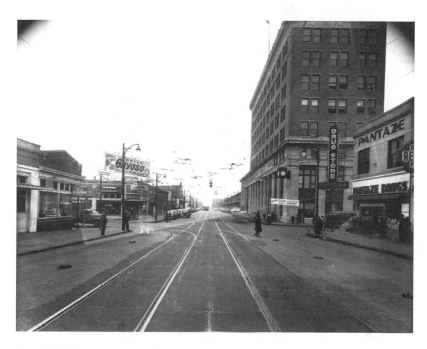

South Main Street and Calhoun Avenue (now G.E. Patterson Avenue) in 1952, looking south. *Courtesy of Memphis and Shelby County Room, Memphis Public Library and Information Center.*

13. Tennessee Brewery

495 Tennessee Street

Built between 1877 and 1890, this ornate, castle-like building was the former home of the Tennessee Brewing Company, at one time the largest brewery in the South. The brewery was originally constructed for the Memphis Brewing Company in 1877; in 1885, it was purchased by the Tennessee Brewing Company, founded by John Schorr. Schorr, whose family had been brewing beer in Germany for over five hundred years, was a former superintendent in a family brewery in St. Louis and came to Memphis at age twenty-two to try his own hand in the family business. The brewery's formal opening took place on June 7, 1885, when forty thousand glasses of free beer were served to the public.

1900 advertisement for the Tennessee Brewing Company. *Courtesy of Memphis and Shelby County Room, Memphis Public Library and Information Center.*

The brewery took advantage of Memphis's pure artesian water and sank a well on the property to tap into the underground aquifer. Within years the brewery was so successful that it expanded, adding its own ice plant and keeping a fleet of twenty horse-drawn wagons busy delivering barrels to saloons all over Memphis. By 1908, the brewery had three bottling machines turning out 1,250 pints a day and had more than five hundred employees.

Trouble began in 1909 when the legislature made Tennessee a dry state, ten years before the Eighteenth Amendment made Prohibition national law in 1919. The brewery stayed open, however, changing its name to the Tennessee Beverage Company and relying on sales of ice and a drink known as NIB, which stood for nonintoxicating beverage. When Prohibition was repealed in 1933, the brewery switched back to beer, and its Goldcrest label became the most popular beer in Memphis and the region. A million-dollar expansion of the facilities followed in 1948 but increased production costs and stiff competition from national brewers led to slumping sales; the brewery closed its doors in 1954.

Chapter 12

Other Places of Interest

This guide has tried to remain focused on downtown Memphis. There are a few sites that for one reason or another did not fit neatly into any of the preceding chapters and are, nonetheless, of special interest to those wanting to learn and experience more of the city's history. Among these are Midtown's Overton Park, the Stax Museum and Mason Temple in South Memphis, the Pink Palace Museum and historic Elmwood Cemetery.

1. OVERTON PARK

2080 Poplar Avenue

The city's premier park, Overton Park, was designed by landscape architect George Kessler; named for John Overton, one of the original founders of Memphis, it opened in 1906. Typical of large urban parks of the early 1900s, Overton Park featured plantings, ponds, rustic bridges, curving drives and bridle paths and a large central greensward; in the northeast corner of the park, Kessler left standing 175 acres of virgin forest as a natural arboretum. The park also at one time featured a Japanese garden, which was destroyed by the parks commission in a wave of anti-Japanese sentiment after the 1941 attack on Pearl Harbor.

In the 1960s and '70s, highway planners proposed building Interstate 40 through the middle of the park. Angry residents of Midtown formed a grass-roots organization and challenged the plan in court, taking the case all the way to the U.S. Supreme Court, which ruled in their favor in the landmark case of *Citizens to Preserve Overton Park v. Volpe.*

Noteworthy sites in Overton Park include:

(1) The Memphis Zoo traces its roots to 1906, when the mascot of the Memphis Turtles baseball team—a black bear named Natch—was tied to a tree in the park. Colonel Robert Galloway, head of the parks commission, spearheaded a drive to build a home for Natch and several other wild animals abandoned in the park in similar fashion. What began as twenty-three cages and a row of concrete bear dens has grown significantly over the years: a Carnivora House for big cats was built in 1909, followed by a Pachyderm House in 1910 and numerous other facilities, including an aquarium. The zoo is currently home to over thirty-five hundred animals of over five hundred different species and is one of only four zoos in the country to exhibit giant pandas from China. Today, most animals are seen not in cages but in ecosystem exhibits mimicking their natural habitats; the zoo consistently ranks among the best in the country.

(2) The Brooks Museum of Art was established in 1916, donated to the city by the widow of Samuel Hamilton Brooks. The museum's oldest section, a Beaux-Arts building designed by New York architect

180

James Gamble Rogers, was inspired in part by the Morgan Library in Manhattan; three large-scale additions, in 1955, 1973 and 1989, have greatly increased the exhibit areas and reoriented the entrance to the south-facing curved façade. The museum opened on May 26, 1916, without a single painting and with no permanent staff. Florence McIntyre, the museum's first director, secured its first exhibition later that year. Gifts and purchases have now brought the collection to over seven thousand works from antiquity to the present, including pieces by Pierre-Auguste Renoir, Thomas Hart Benton and Auguste Rodin along with works of African and Latin American art.

(3) Behind the museum resides the Memphis College of Art, which was officially founded in 1936 when the faculty of the James Lee Memorial Academy of Arts split up in a dispute over modern art. The traditionalists, led by Florence McIntyre, remained at the Lee academy, but the city, surprisingly, supported the upstart modernists and created a new school, the Memphis Academy of Arts. The school, now known as the Memphis College of Art, moved to this location in Overton Park in 1958. The Rust Building, named for the school's longtime director, Ted Rust, was the winning design (by William Mann and Roy Hanover) in a competition juried by Philip Johnson and Paul Rudolph and remains one of Memphis's best examples of mid-century modern architecture.

(4) The Overton Park Shell was built in 1936, one of more than two dozen amphitheaters constructed by the WPA during the Depression; it is one of the few remaining today. Based on similar designs in New York, Chicago and St. Louis, it features excellent acoustics and a generally pleasing design. The Memphis Symphony Orchestra performed in the shell's opening night concert before a crowd of six thousand.

The shell's most famous concert, however, was undoubtedly Elvis Presley's performance here on Friday, July 30, 1954. It was his first paid concert appearance, only a few weeks after the release of his first record. Advertised as a Hillbilly Hoedown, the show featured headliner Slim Whitman, along with several other country music artists. On the strength of the phenomenal local success of *That's All Right*, Elvis, along with his guitarist Scotty Moore and bass player

Overton Park Shell. *Courtesy the author.*

Bill Black, was booked to open the show. Elvis's name was still so unfamiliar that it was misspelled in advertisements and concert posters as "Ellis Presley."

The show began at 8:00 p.m. with *That's All Right*. On stage, Elvis stood up on the balls of his feet and shook his leg in time with the music, something he often did in the studio. To his shock and surprise, the girls in the audience went crazy. Elvis mania was born that night. As Scotty Moore described it, "he was kind of jiggling. That was just his way of tapping his foot. Plus I think with those old loose britches that we wore…you shook your leg, and it made it look like all hell was going on under there."

The screaming continued during their next song, *Blue Moon of Kentucky*, and when Elvis got offstage with the crowd going wild, he asked the concert promoter, Bob Neal, "What'd I do? What'd I do?" Neal is said to have replied, "I don't know, but go back out there and do it again."

2. PINK PALACE

3050 Central Avenue

The Pink Palace is a rather fanciful name given to this mansion of pink Georgia marble built by Memphis grocery-store magnate and entrepreneurial innovator Clarence Saunders. A Virginian by birth, Saunders came to Memphis in 1904 as a grocery salesman; twelve years later, in 1916, he opened his first revolutionary Piggly Wiggly grocery store downtown on the corner of Main Street and Jefferson Avenue. As the first modern supermarket, Piggly Wiggly changed not only the shopping experience but revolutionized the nature of modern marketing and advertising. As to the origins of the name Piggly Wiggly itself, Saunders was intriguingly silent, though once when asked why he had chosen such an unusual name for his stores, his reply was simply, "So people will ask that very question."

By 1922, Piggly Wiggly had grown to 1,241 stores in 29 states with sales of almost $200 million. Saunders began construction of this grand mansion, but in 1923, before construction was completed, Saunders went bankrupt in a stock market gambit and lost control of his Piggly Wiggly company. The unfinished house fell into the hands of his creditors and was eventually donated to the city. After spending $150,000 to complete the building, it opened as the Memphis Museum of Natural History and Industrial Arts in March 1930.

The museum was officially renamed the Pink Palace Museum in 1967. It features an exact replica of the original Jefferson Avenue Piggly Wiggly store, along with exhibits and artifacts from the mid-South's natural and cultural history, an IMAX theatre and a planetarium.

3. STAX MUSEUM OF AMERICAN SOUL MUSIC

926 McLemore Avenue

Memphis's reputation as a city of music and musical innovation rests not only on Elvis Presley, Sun Records and the city's mythical status as the Home of the Blues, but also on the phenomenal

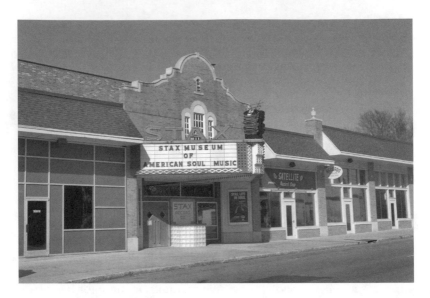

Stax Museum of American Soul Music. *Courtesy the author.*

output of Stax Records, a home-grown studio in South Memphis. Stax Records became renowned for soul music, but the studio was founded, ironically, by two white businesspeople, Jim Stewart and his sister, Estelle Axton.

Jim Stewart was a banker and bond salesman, working at the First National Bank downtown while moonlighting as a fiddle player with several local country bands. Like many other Memphians in the wake of Elvis Presley's phenomenal success and the rise of Sun Records on Union Avenue, he dreamed of making it in the music business. In 1958, Stewart convinced his sister, Estelle, to take out a second mortgage on her house for $2,500 to pay for recording equipment and set up a makeshift studio; in 1960, they relocated here to the former Capitol movie theater on McLemore Avenue. In the old theater they combined a studio with a record shop, run by Axton; the sloping theater floor with carpeted walls and heavy bass speakers would create the distinctive sound of Stax recordings.

Initially called Satellite Records, the studio changed its name to Stax (a combination of Stewart and Axton) in 1961. Regional success with a recording by Rufus Thomas and his daughter, Carla

Other Places of Interest

(*Cause I Love You*), led to a national distribution deal with Atlantic Records. Neighborhood kids hanging out at the record store were welcomed into the studio, including a young Booker T. Jones, who lived a few streets away and attended nearby Booker T. Washington High School. Jones would join guitarist Steve Cropper and bassist Lewie Steinberg, both friends and band mates of Estelle's son, and veteran drummer Al Jackson to form the group Booker T. and the MGs; later, Steinberg would be replaced by Donald "Duck" Dunn. In 1962, the band recorded *Green Onions*, an instrumental song that became a national number one hit, but the band was perhaps most influential as the de facto studio house band, playing on hundreds of hit records for other artists and, in the process, defining the distinctive "groove" of the new genre of soul music. The band was racially integrated, with two black members (Jones and Jackson) and two white members (Cropper and Dunn), which was highly unusual at the time but reflected the welcoming, open-door policy of Stax Records.

Stax would produce such major artists as Otis Redding, Isaac Hayes and Sam & Dave, among others. In the late 1960s a trilogy of events—Redding's death in a plane crash in 1967, the loss of the studio's distribution arrangement with Atlantic Records and racial unrest in the city following the assassination of Dr. Martin Luther King Jr.—spelled the beginning of the end for Stax, although the studio continued to release hits into the mid-1970s. After the studio closed its doors in 1976, the building lay vacant for a number of years and was torn down in 1989.

Over a decade later the Stax Museum of American Soul Music was constructed at the site and opened in 2003. A replica of the original building, the Stax Museum features exhibits on the history of Stax and soul music in general and hosts various music-related community programs and events; on display are Isaac Hayes's 1972 gold-plated Cadillac El Dorado, an authentic one-hundred-year-old Mississippi delta church and clothing and personal items from a wide range of stars. An afternoon at the museum is highly recommended.

4. MASON TEMPLE

938 Mason Street

Built in 1940, Mason Temple is the world headquarters of the Church of God In Christ, a historically African American Pentecostal denomination. It was one of the focal points of civil rights activities in Memphis during the 1950s and 1960s and was the site of Martin Luther King Jr.'s stirring "Mountaintop" speech on April 3, 1968—the evening before his assassination—that seemed to foreshadow his impending death:

> *We've got some difficult days ahead. But it doesn't matter with me now. Because I've been to the mountaintop. And I don't mind. Like anybody, I would like to live a long life. Longevity has its place. But I'm not concerned about that now. I just want to do God's will. And He's allowed me to go up to the mountain, and I've looked over, and I've seen the Promised Land. I may not get there with you, but I want you to know tonight, that we, as a people, will get to the Promised Land.*

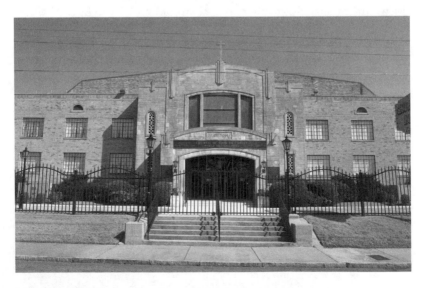

Mason Temple. *Courtesy the author.*

5. ELMWOOD CEMETERY

824 South Dudley Street

Elmwood Cemetery was founded in 1852 as a garden cemetery on the outskirts of the city, one of the first of its kind in the South. In the mid-nineteenth century, as Memphis grew in population and physically expanded, burial grounds downtown—Winchester Cemetery in the north and Morris Cemetery in the south—were becoming crowded and considered a hindrance to business expansion. A spacious, rural, park-like area was considered to be both healthier as well as more consoling to family and loved ones, a place where the living could commune with nature as a way of finding life in death. To this end a Cemetery Association was formed and forty acres of wooded rolling hills purchased two miles outside the city limits; an additional forty acres was added after the Civil War.

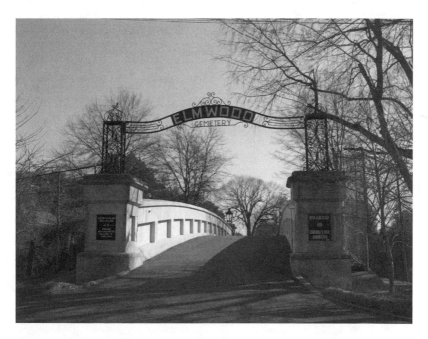

Elmwood Cemetery, Morgan Bridge. *Courtesy the author.*

The name Elmwood was chosen out of a hat full of names in 1852. The Cemetery Association was said to be pleased with the name, although it then had to scramble to order elm trees from New York to plant among the native oaks and magnolias. Entrance to the cemetery is over the high-arched Morgan Bridge, built in 1903; immediately to the left upon crossing the bridge is the cemetery office, known as the Phillips Cottage, built in 1866, a fine example of Victorian carpenter gothic architecture. The bell atop the brick vault beside the cottage has rung at every processional since its placement at the cemetery entrance in the early 1870s.

The first burial was in 1853, of a Mrs. R.B. Berry. Today, over seventy-five thousand people are buried in Elmwood from all walks of life, including politicians, madams, bankers, blues singers, educators, outlaws, millionaires and paupers. Since its earliest days, the cemetery has been inclusive; there are whites and blacks, Irish, Chinese, German, Greek and Mexican immigrants as well as those of Catholic, Protestant, Jewish and Muslim faiths. It is the final resting place of four U.S. senators, twenty-two mayors of Memphis, two Tennessee governors and veterans of every American war since the Revolution. Over one thousand Confederate veterans are buried in lots donated by the Cemetery Association (the last interment was in 1940); some seven hundred Union soldiers were buried here also, although most were moved to the Memphis National Cemetery in 1866. Annie Cook, a well-known madam who opened her brothel as a makeshift infirmary and died tending the sick during the yellow fever epidemic of 1878, lies near thousands of anonymous fever victims in unmarked graves; the cemetery is also the final resting place of such prominent citizens as E.H. Crump, Robert Church Sr. and historian and writer Shelby Foote.

A one-hour driving tour of the cemetery is available from the office, providing an excellent background on Elmwood's interesting collection of monuments and the stories of those laid to rest here.

Suggested Reading

Bond, Beverly and Janann Sherman. *Memphis in Black and White.* Charleston, SC: Arcadia Publishing, 2003.

Coppock, Helen M. and Charles W. Crawford, eds. *Paul R. Coppock's Mid-South, Vol. I–Vol. IV.* Memphis: Paul R. Coppock Publication Trust, 1985–1994.

Coppock, Paul R. *Memphis Memories.* Memphis, TN: Memphis State University Press, 1980.

———. *Memphis Sketches.* Memphis, TN: Friends of Memphis and Shelby County Libraries, 1976.

Dowdy, Wayne G. *Mayor Crump Don't Like It: Machine Politics in Memphis.* Jackson: University of Mississippi Press, 2006.

Escott, Colin with Martin Hawkins. *Good Rockin' Tonight: Sun Records and the Birth of Rock 'n' Roll.* New York: St. Martin's Press, 1991.

Gordon, Robert. *It Came From Memphis.* Boston: Faber and Faber, 1995.

Guralnick, Peter. *Last Train to Memphis: The Rise of Elvis Presley.* Boston: Little, Brown, 1994.

———. *Sweet Soul Music: Rhythm and Blues and the Southern Dream of Freedom.* Boston: Little, Brown, 1999.

Handy, W.C. *Father of the Blues: An Autobiography.* New York: Da Capo Press, 1941.

Harkins, John E. *Historic Shelby County: An Illustrated History.* San Antonio: Historical Publishing Network, 2008.

————. *Metropolis of the American Nile: Memphis and Shelby County.* Memphis, TN: West Tennessee Historical Society, 1982.

Johnson, Eugene and Robert Russell Jr. *Memphis: An Architectural Guide.* Knoxville: University of Tennessee Press, 1990.

Lanier, Robert. *Memphis in the Twenties: The Second Term of Mayor Rowlett Paine, 1924–1928.* Memphis: Zenda Press, 1979.

Lauderdale, Vance. *Ask Vance.* Memphis: Bluff City Books, 2003.

Magness, Perre. *Good Abode: Nineteenth Century Architecture in Memphis and Shelby County, Tennessee.* Memphis: Junior League of Memphis, 1983.

————. *Past Times: Stories of Early Memphis.* Memphis: Parkway Press, 1996.

Raichelson, Richard. *Beale Street Talks.* Memphis: Arcadia Records, 1999.

Sigafoos, Robert. *Cotton Row to Beale Street: A Business History of Memphis.* Memphis, TN: Memphis State University Press, 1964.

About the Author

Attorney and business owner Bill Patton is the founder of Memphis-based tour company Backbeat Tours (www.backbeattours.com). His poetry and short fiction has appeared in the *Potomac Review* and other journals. He lives in Midtown Memphis with his wife and two dogs.

Please visit us at
www.historypress.net